MW00636044

LEGENDARY L

— OF —

CINCINNATI

OHIO

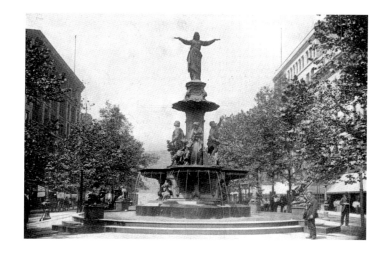

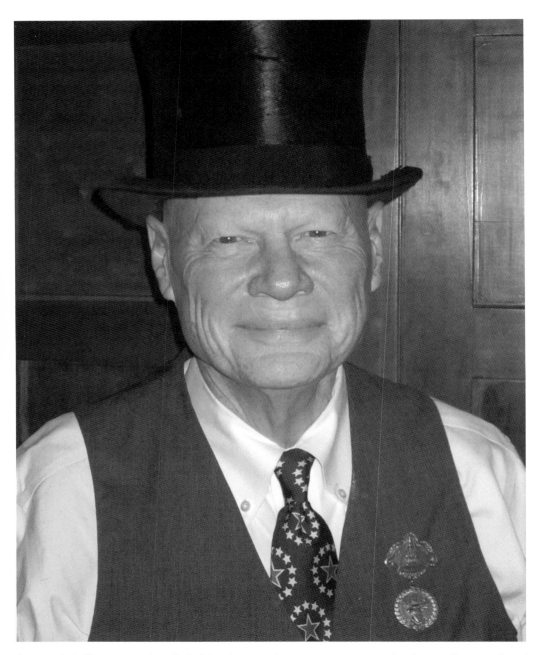

For nearly half a century, Jim Tarbell has been a ubiquitous presence in the Queen City in political campaigns, celebrations, cultural events, and every other aspect of civic life. Calling him a civic booster does not even begin to describe his contributions. He is a politician, neighborhood preservationist, historian, concert promoter, idealist, activist, provocateur, thorn, and visionary. Tarbell's top hat is only part of the haberdashery that marks the man. Has anyone ever loved Cincinnati more passionately?

Page 1: The Tyler Davidson Fountain, Cincinnati's most famous landmark since 1871.

LEGENDARY LOCALS
— OF —

CINCINNATI

OHIO

KEVIN GRACE

LEGENDARY
LOCALS

To my friends Tom White, Jack Klumpe, Greg Hand, and Stuart Hodesh, the best Cincinnati storytellers I know

Copyright © 2011 by Kevin Grace
ISBN 978-1-4671-0002-1

Published by Legendary Locals, an imprint of Arcadia Publishing
Charleston, South Carolina

Printed in the United States of America

Library of Congress Control Number: 2011936428

For all general information, please contact Arcadia Publishing:
Telephone 843-853-2070
Fax 843-853-0044
E-mail sales@arcadiapublishing.com
For customer service and orders:
Toll-Free 1-888-313-2665

Visit us on the Internet at www.arcadiapublishing.com

On the Cover: From left to right:
(TOP ROW) Annie Laws, educator (see page 56); Theda Bara, actress (see page 53); Bertha Baur, educator (see page 51); Ted Berry, civil rights leader (see page 96); Ezzard Charles, boxer (see page 89).
(MIDDLE ROW) Christian Moerlein, brewer (see page 43); Gustave Eckstein, physiologist (see page 81); Mary Emery, philanthropist (see page 64); William Holmes McGuffey, educator (see page 11); Erich Kunzel, conductor (see page 117).
(BOTTOM ROW) Louis Hudepohl, brewer (see page 27); Jimmy Nippert, collegiate football player (see page 69); Pete Rose, baseball player (see page 104); Marian Spencer, civic activist (see page 119); and Dick Von Hoene, entertainer (see page 114).

CONTENTS

ACKNOWLEDGMENTS

For their assistance in more ways than they can ever know, thank you to Kevin Proffitt, Michelle Wirth, Suzanne Maggard, Janice Schulz, Lauren Fink, Laura Laugle, Bobbie Unnerwehr, Doris Haag, Dottie Stover, Lisa Ventre, Mark Palkovic, Linda Hand, Jacob Hand, Chris von Volborth, Liz von Volborth, Mary Killen, Rod Apfelbeck, Herman Luckner, and Conni Berns. I owe a special thanks to Bob Elkus for sharing his memories of Cincinnati boxing and city life in the 1950s. To all my students who have afforded me the privilege of being part of their lives over the years, here's a glass raised to you. And, of course, thanks always to my wife, Joan Fenton, my children Josh, Sean, Courtney, Bonnie, and Lily, my daughter-in-law ZoEtta, and my granddaughter Honora.

Unless otherwise noted here, all images are from the collection of the author. Pages 12, 13 (bottom), 14 (bottom), 18, 19 (top), 21, 36 (bottom), 38 (bottom), 39 (bottom), 57 (bottom), 69, 78 (top), 108 (bottom), 117 (top) courtesy of the Archives & Rare Books Library, University of Cincinnati. Pages 92–94, 95 (bottom), 97–106 (top), 109 (top), and 112, courtesy of Jack Klumpe. Pages 78 (bottom), 79, 95, 116 (bottom), 120–121, courtesy of Public Relations, University of Cincinnati; Page 42, courtesy of American Jewish Archives; Page 75, courtesy of the Henry R. Winkler Center for the History of the Health Professions, University of Cincinnati, bottom photo by David Collins; Page 88, courtesy of Bob Elkus; Page 118 (top), courtesy of LaRosa's Restaurants; Page 118 (bottom), courtesy of the Charles and Marge Schott Foundation; Page 123, courtesy of Gene Kritsky; Page 124, courtesy of Dorothy Smith; and Page 125, courtesy of Linda Hand.

INTRODUCTION

Cincinnati is a city rich in personality but often in conflict with its history and geography. Straddling the North and the South, at times the Queen City has been hard put to determine which region best defines it. Though settled in the late 18th and early 19th centuries by early pioneers from the eastern states of primarily Anglo-Saxon stock, it was the immigrant German, Irish, Italian, and Eastern European populations who along with African Americans and Appalachians have most strongly characterized it over the past two centuries. Cincinnati's people have combined all these influences to build a home that is a fascinating and intriguing place to live. Of course, the Queen City has faced the major urban problems every other American city has: racial disharmony, infrastructure decline and renewal, economic ups and downs, population shifts, and struggling schools. But Cincinnati has also been a vibrant place of achievement and innovation, a place where problems are solved.

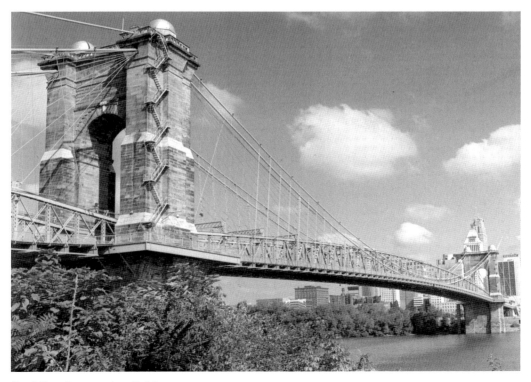

Roebling Suspension Bridge
Built in 1866, the John A. Roebling Suspension Bridge spans the Ohio River between northern Kentucky and the city of Cincinnati.

There have been a fair number of scoundrels, scalawags, and criminals: George Cox and George Remus, Anna Marie Hahn and Edythe Klumpp. They keep us on our toes, or as an English policeman once commented on a rabble-rouser speaking from a soapbox on a London corner, "Every dog needs a few fleas to keep it scratching." Cincinnati has been home to more than a few dyspeptic types: Daniel Drake, Charles McMicken, and Timothy Day are in their number. These individuals, and others like them, accomplished a great amount of good, but not without a few bilious sentiments. On the other hand, the city has had a great number of outright philanthropists such as Mary Emery, Louise Nippert, Patricia Corbett, and Carl Lindner. And their ranks keep growing. Civil rights activists and civic leaders have always come to the fore as well, as have scientists, teachers, and businessmen. Then there are the everyday people who are not household names, but still make an impression on Cincinnati. They are all uncommon in that they have contributed to the common good. Here are their stories.

Though this book is divided into chapters indicating eras, the Legendary Locals are not always presented in a precise chronology. Their experiences and achievements often crossed several decades. And the men and women in these pages are not necessarily the richest, the most artistic, the best athletes, the most accomplished businessmen, the most innovative scientists, or the most dedicated community leaders. Above all, they were—or in some cases, still are—people whose stories are interesting and who have contributed to the tapestry of Cincinnati's cultural makeup. Certainly there are many, many others who could join their ranks.

Cincinnati is rich in another particular way. Throughout its history, it has been quite fortunate to claim many fine chroniclers of its stories, and a great debt is owed to the dozens of volumes they have written. In particular, this book has benefitted from *Cincinnati: A Guide to the Queen City and Its Neighbors* by the WPA Writer's Project (1943); *The Serene Cincinnatians* by Alvin F. Harlow (1950); Dick Perry's *Vas You Ever in Zinzinnati?* (1966); Daniel Hurley's essential *Cincinnati: The Queen City* (1982); *Cincinnati Then and Now* by Iola Hessler Silberstein (1982); *Workers on the Edge: Work, Leisure, and Politics in Industrializing Cincinnati, 1788–1890* by Steven J. Ross (1985); and Barry M. Horstman's excellent *100 Who Made a Difference: Greater Cincinnatians Who Made a Mark on the 20th Century* (1999). Two recent volumes that will become vital to learning about Cincinnati are Michael D. Morgan's *Over-the-Rhine: When Beer Was King* (2010) and *Cincinnati's Incomplete Subway: The Complete Story* by Jake Mecklenborg (2010). And no appreciation of Cincinnati would be complete without a look at the more than 40 pictorial volumes produced by Arcadia Publishing over the past decade.

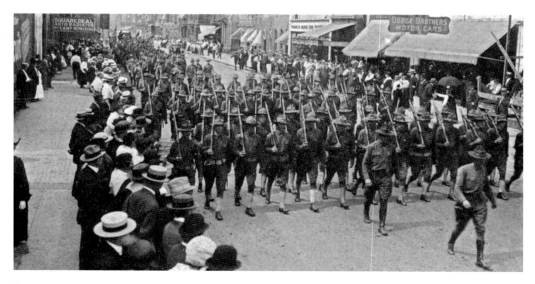

Following a speech by William Howard Taft, soldiers march down Race Street in 1917 during a Red Cross War Fund campaign in Cincinnati.

CHAPTER ONE

Building the Queen City

With its settlement in 1788, Cincinnati found itself on the frontier edges of the nation, part of the recently incorporated Northwest Territory. The earliest pioneers were of New England and Middle Atlantic stock, ready to set up farming in the Ohio Valley and to establish their homes and businesses along the Ohio River. In the basin that formed the city, Cincinnati grew at a fairly reasonable pace, with manufacturing in place by the early 1800s, churches on the corners, and an active trade on the riverfront.

And with the burgeoning city came an impetus to make it a true metropolis. Daniel Drake received a charter to found a medical school in 1819, a year which also witnessed the creation of the Cincinnati College. An observatory and a mechanics institute soon followed. Cincinnati became a major publishing center. The business of the city was trade, and two of the commodities the citizens wished to trade in were education and culture. In the antebellum years, natural history societies, agricultural societies, arts societies, and music societies were begun. One could reasonably infer that Cincinnati was a city of societies, and the number would grow even larger as fresh groups of people arrived each year with their own ethnic, religious, and occupational identities.

And in those years, Cincinnati became "Porkopolis" for its swine trade. The thousands of pigs herded down the streets on their way to slaughter gave the city a new identifying characteristic that would last for the next few decades. In fact, that piggish moniker has never disappeared. Even in the 21st century, Cincinnati celebrates its porcine heritage with statuary and advertising.

Nicholas Longworth

Longworth came to Cincinnati in 1804, and after making a fortune as a lawyer and banker, turned his hand to viticulture because he believed the Ohio River valley would prove a fertile area for grape cultivation. His special grape was the "Catawba," from which he made a sparkling wine that won favor in America and in Europe. Bringing in Swiss and German immigrants to tend his vineyards, Longworth established settlements for them along the hillside ridges. One such area below Mt. Auburn was dubbed "Little Bethlehem" for the German Mennonites who lived there. They isolated themselves almost completely from the rest of the city, and after the demise of Longworth's winemaking from blights, Little Bethlehem disappeared and became part of the city's folklore.

Daniel Drake

Irascible to a fault and brilliant to a very large degree, Dr. Daniel Drake set up his medical practice in Cincinnati in 1807. In 1819, he helped create the Medical College of Ohio and then established the Commercial Hospital and Lunatic Asylum, realizing the value of practical clinical experience for his students. Unable to get along with faculty, he was forced to leave the college, whereupon he started other medical schools, from which he was asked to leave as well. However, he left a solid legacy of pioneering research in medicine and natural history.

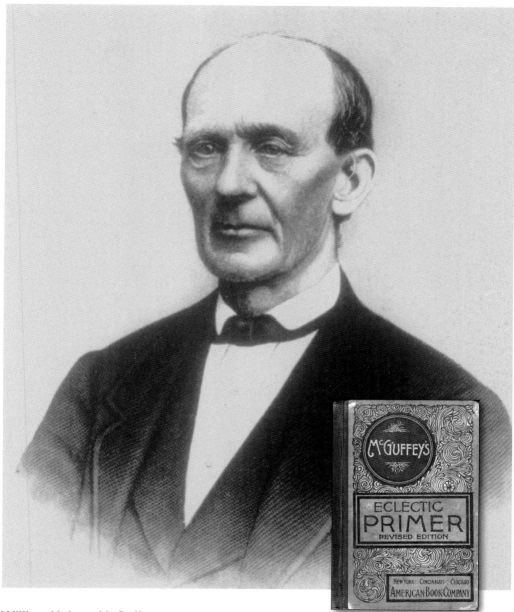

William Holmes McGuffey

The creator of the famous McGuffey readers (it is thought that most of them were written by his brother Alexander and Harriet Beecher Stowe's sister Catherine), William Holmes McGuffey became president of Cincinnati College in 1836 and published the *Eclectic texts*. A popular lecturer on moral philosophy, McGuffey often had to turn away people who came to hear him speak in his classrooms, leaving them craning to hear his muffled voice from outside. In his later post as president of Ohio University, his fractious nature turned the faculty against him, eventually landing him at the University of Virginia. One of the most popular series of schoolbooks in American history, McGuffey's readers sold more than 100 million copies in the 19th century.

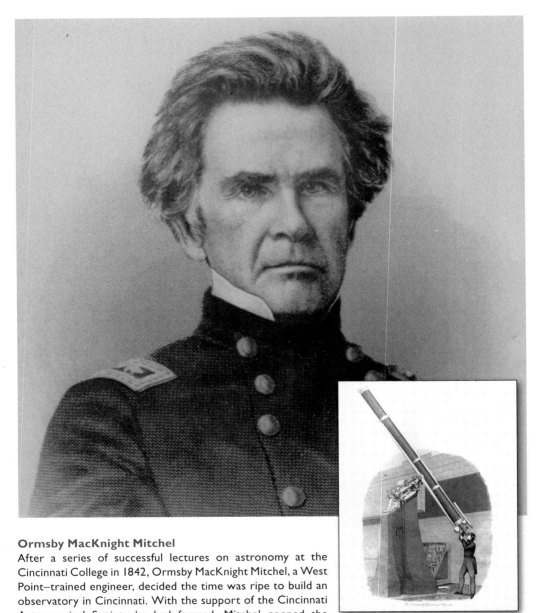

Ormsby MacKnight Mitchel

After a series of successful lectures on astronomy at the Cincinnati College in 1842, Ormsby MacKnight Mitchel, a West Point–trained engineer, decided the time was ripe to build an observatory in Cincinnati. With the support of the Cincinnati Astronomical Society he had formed, Mitchel opened the Cincinnati Observatory on Mt. Ida, a neighborhood bluff to the east of downtown. John Quincy Adams made the trek to dedicate the venture, and in his honor Mt. Ida was renamed Mt. Adams. The giant refractor telescope that Mitchel installed was even used to illustrate the word "telescope" in *Webster's Dictionary Dictionary* (shown in inset). With the outbreak of the Civil War, Mitchel was called to active duty in the Union cause, serving as a general in the South Carolina campaigns, where he died of yellow fever in 1862. What he set in motion in Cincinnati, however, had a lasting impact on astronomical studies. The Observatory continued, eventually relocating to its present location on Mt. Lookout in 1873 in buildings designed by architect Samuel Hannaford. It was through the efforts of the Observatory that standard time was established, as well as the beginnings of the National Weather Service.

Timothy C. Day

Timothy Day was once referred to as "one of the most militant figures in the political history of Cincinnati." The city's early history shaped his views, but they were also steeped in abolitionism, nativism, and everyday orneriness. Day's early occupation was as a printer, and when his older brother died in 1850, he took over his sibling's half-ownership of the *Cincinnati Enquirer*. There he found his political voice, railing against the extension of slavery into the Territories and generally making a nuisance of himself in the Democratic Party, though he represented it in Congress in 1854. Day bolted from the Democrats for the antislavery Republicans in 1858 and ran unsuccessfully for Congress. As the Civil War broke out, he championed Abraham Lincoln and served as a colonel of local African American troops. But Day's legacy to the city extended well beyond politics. He was a firm believer in the power of libraries, and to that end, he endowed the Ohio Mechanics Institute (pictured here in the 1890s) with the funds for a permanent library.

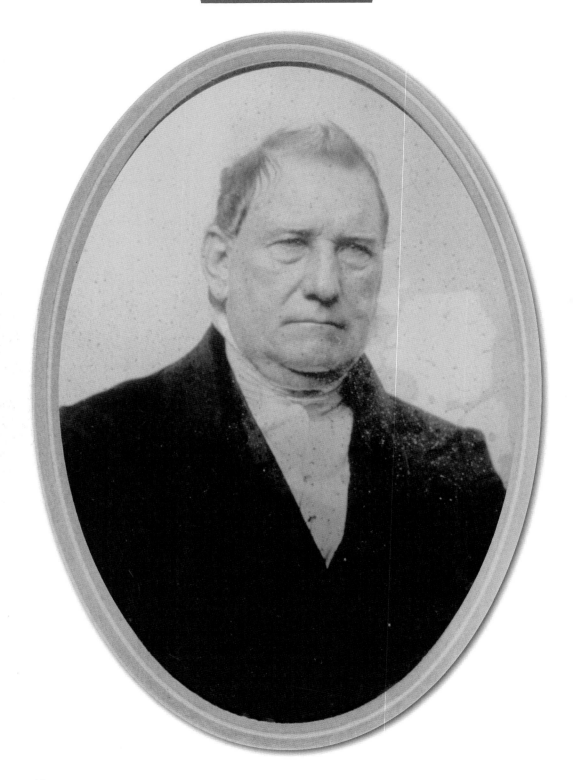

Charles McMicken

It seems that despite their accomplishments and civic benevolence, many of Cincinnati's early movers and shakers were just downright prickly. Charles McMicken certainly was. A secretive and circumspect fellow with business interests in Cincinnati and down the Ohio and Mississippi Rivers to Louisiana, McMicken's legal entanglements sometimes included the name "Tricky Charlie" for his habit of obfuscation when asked his place of legal residence. McMicken was born a Presbyterian but embraced Methodism, owned slaves but gave land to free people of color, and had a notion that the arts were important so he donated funds to foster them in Cincinnati. Most importantly, his lack of formal education made him appreciate its necessity: Upon his death from pneumonia in 1858, a million dollars was bequeathed to the City of Cincinnati to found a university. Twelve years later, McMicken's funds helped establish the University of Cincinnati. When he chose to stay in Cincinnati, McMicken took up residence in the modest home of his nephew, Andrew. McMicken owned both the house and the property (above), and its hillside would become the location for the first University of Cincinnati building constructed in 1875.

J.P. Ball
Born a free man of color in Virginia in 1825, James Presley Ball was one of the earliest daguerrotypists in the country. He set up a photography studio in Cincinnati in 1845, but after the business failed, he became an itinerant portraitist, returning to the Queen City in 1849 and opening a new studio with his brother Thomas. Ball photographed many of the prominent Cincinnatians of his day, as well as such notables as Ulysses S. Grant, Charles Dickens, P.T. Barnum, and Queen Victoria, and displayed his daguerreotypes at fairs and in exhibition galleries. Finding himself in the hotbed of abolitionism that was Cincinnati in the antebellum years, Ball also supported publications railing against the slave trade. After the Civil War, Ball lit out for the West, eventually landing in Seattle where he again found favor for his work. In 1902, Ball moved to Hawaii, where he died in 1904.

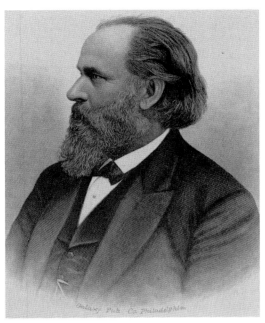

Adolph Strauch

The architect of Cincinnati's beautiful Spring Grove Cemetery and Arboretum (below), Adolph Strauch believed that a cemetery could be a work of art, not just rows of headstones and monuments. The Prussia-born Strauch came to Cincinnati in 1852, first working as a horticulturalist for wealthy property owners. Given the commission to design the rolling landscape of Spring Grove in 1854, he created lakes and groves of trees, making the graveyard a place of pastoral beauty. With the growth of Spring Grove and the monuments designed for the dead, it became an outdoor sculptural museum as well.

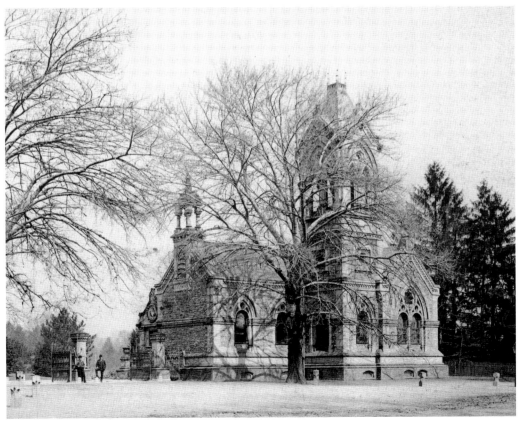

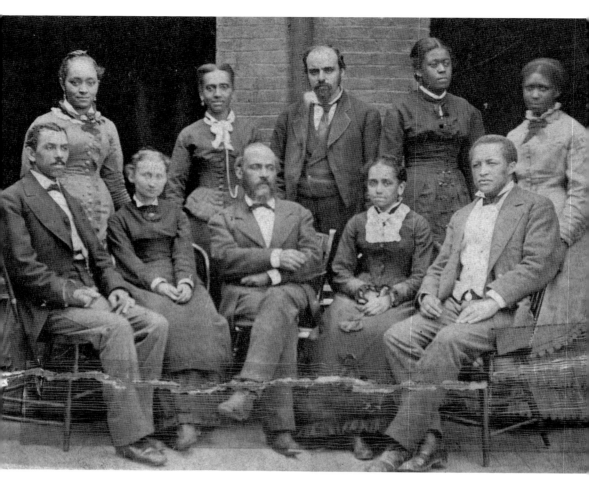

Peter H. Clark

It was once claimed that between the years before the Civil War until the 1890s, there was not an African American teacher in Cincinnati who had not been trained by Peter Humphries Clark. Born in 1825, the grandson of explorer William Clark and the son of one of Clark's freed slaves, Peter Clark worked as a barber and a clerk before becoming a schoolteacher in 1852. At the time, there were a growing number of African American schools in the Cincinnati area, so after his regular school day was completed, Clark would offer courses to advanced students in order to fill the demand for teachers. Actively involved in local politics, he copublished a newspaper, the *Cincinnati Afro-American*, and following the Civil War, advocated the establishment of a separate high school for African Americans, the result being the founding of Gaines High School in 1866. This image of the Gaines faculty was discovered in 2011 and shows Clark seated in the middle with his arms crossed.

Stephen Foster

Stephen Collins Foster, America's popular music bard in the mid-19th century, came to Cincinnati in 1846 to work as a bookkeeper for the steamboat company owned by his brother William. Already dreaming of a composer's life, Foster had grown up in Pennsylvania and began writing songs in his early teen years. After a brief stint at Jefferson College (now Pennsylvania's Washington & Jefferson College), Foster made his way to the riverfront in Cincinnati (below). So, while clerking brought him a living, songwriting brought him pleasure, especially with the frequent minstrel shows and riverboat performances he was exposed to. The river life afforded him no small inspiration, and it was in Cincinnati where he wrote what would become one of the most popular songs in American music history, "Oh Susanna." The song would travel down river and overland to become the signature tune of the California Gold Rush. In Cincinnati, Foster became acquainted with the musical troupe the Christy Minstrels and wrote several songs for them. Preparing bills of lading would never do for him,

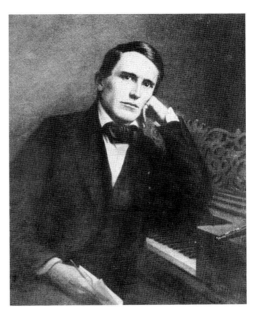

and in truth he was probably not very adept at it, so in 1849 he signed a contract with the Minstrels and returned to Pennsylvania. Shortly thereafter he moved to New York and found the poverty of a composer's life. His wife and daughter left him to return to Pennsylvania, and Foster died in Bellevue Hospital, bleeding from a cut he sustained in a fall in his decrepit hotel room. A piece of paper was found in his wallet with the simple words "Dear friends and gentle hearts."

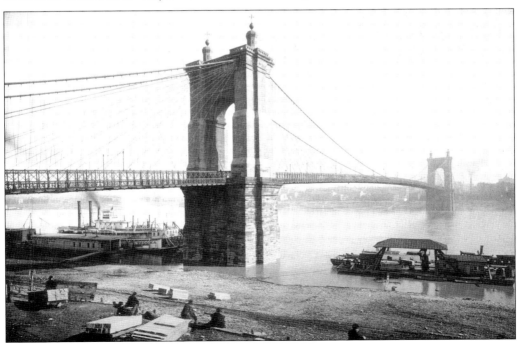

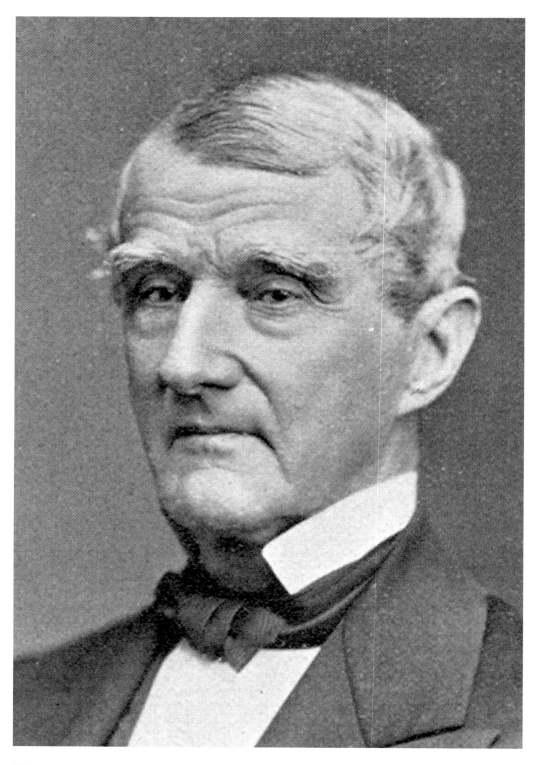

Reuben R. Springer (LEFT)

Born in 1800, Reuben Runyan Springer rose from a simple position as a store clerk to a prominent man of wealth earned through the grocery trade and astute real estate investments. He was also a man of refined musical tastes and indulged them as often as he could, sponsoring the city's famous May Festivals. Springer also contributed to literary endeavors and to education. But he is best known in Cincinnati history as the man behind the construction of Music Hall and the establishment of the Cincinnati College of Music. There is a story that has survived the past century and a half that the idea of Music Hall came to Springer as the result of a spring storm in 1875. Sitting in the Saengerfest Halle trying to enjoy the performances, he was agitated by the noise of hail and rain on the tin roof of the building. The concert was stopped until the storm passed. Springer resolved that he would do something about constructing a proper concert hall in Cincinnati, and so provided the initial funds for the grand Music Hall.

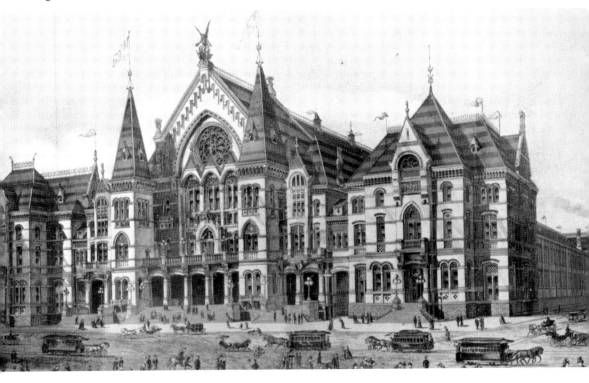

Music Hall

Reuben Springer stated that he would give $125,000 in matching funds for a hall to be built on city property. The site, on Elm Street in Over-the-Rhine, would be Springer's crowning glory and the physical symbol of the musical arts in the Queen City. As is often the case with large public building projects however, there were delays and cost overruns. Springer kept digging ever deeper into his pockets to make the concert venue a reality. In addition to his initial gift, he ended up donating another $100,000 and insisted the structure be named Cincinnati Music Hall instead of after him, as some civic leaders desired. In its history the Gothic building has hosted symphony performances, pop concerts, community dances, boxing, track meets, expositions, trade shows, and ballet: and, of course, the Cincinnati May Festivals. Lovingly cared for by the Society for the Preservation of Music Hall, which oversees renovations and maintenance, it was also named a venue for the 2012 World Choral Games held in Cincinnati. Add to that a mysterious ghost or two and you have an indispensable part of Queen City lore

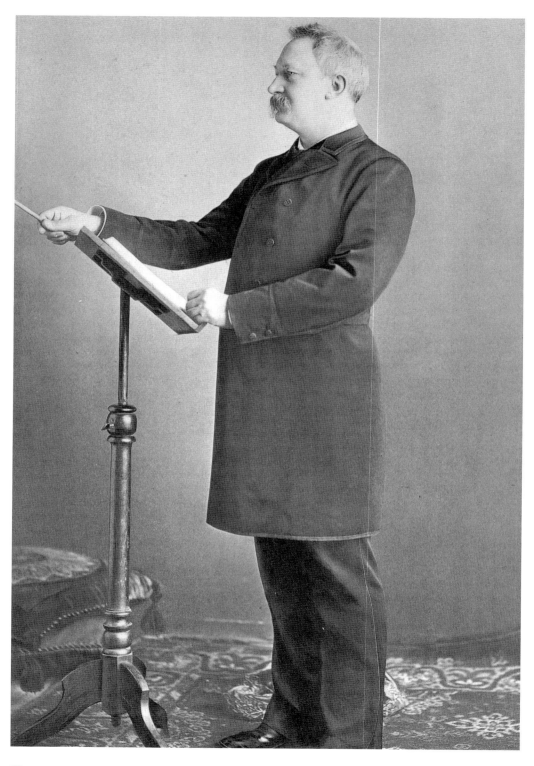

Theodore Thomas (LEFT)

In the Cincinnati music scene of the 19th century, conductor Theodore Thomas took center stage. In 1845, the young Thomas came with his family from Germany to America. His father was a bandleader and violinist in their native land and was looking for greater opportunities across the Atlantic. Thomas was also a violinist, and along with his father, joined the Navy Band in 1848 at the tender age of 13. Shortly thereafter, Thomas began a career separate from his father's and played for several theater orchestras before becoming a conductor himself. After several years as a musical director in New York, Thomas was brought to Cincinnati as director of the fledgling College of Music, where his artistic temperament led to an often acrimonious relationship with the board of directors. One popular editorial cartoon of the time showed him conducting an orchestra for an audience of pigs, a reference to Cincinnati's Porkopolis nickname, earned because of its history of pork production. It also implied that Thomas had landed in a cultural backwater. With the support of Reuben Springer, Thomas had first become known in the city in 1873 as the conductor of the May Festival. Even after he left Cincinnati for Chicago, where he gained national fame as the conductor of the Chicago Symphony Orchestra, he continued to come back to Cincinnati every other spring, conducting the biennial May Festivals until 1904. After the 1904 festival, Thomas returned to Chicago where he died the following year.

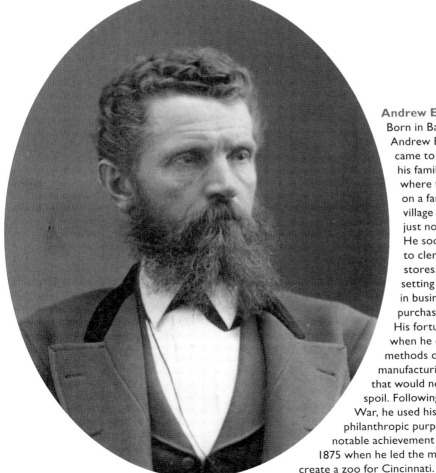

Andrew Erkenbrecher
Born in Bavaria in 1821, Andrew Erkenbrecher came to America with his family in 1835, where they worked on a farm in the village of Carthage just north of the city. He soon left the farm to clerk in various stores, eventually setting himself up in business with the purchase of a mill. His fortune was made when he developed new methods of efficiently manufacturing cornstarch that would not quickly spoil. Following the Civil War, he used his wealth for philanthropic purposes, his most notable achievement occurring in 1875 when he led the movement to create a zoo for Cincinnati.

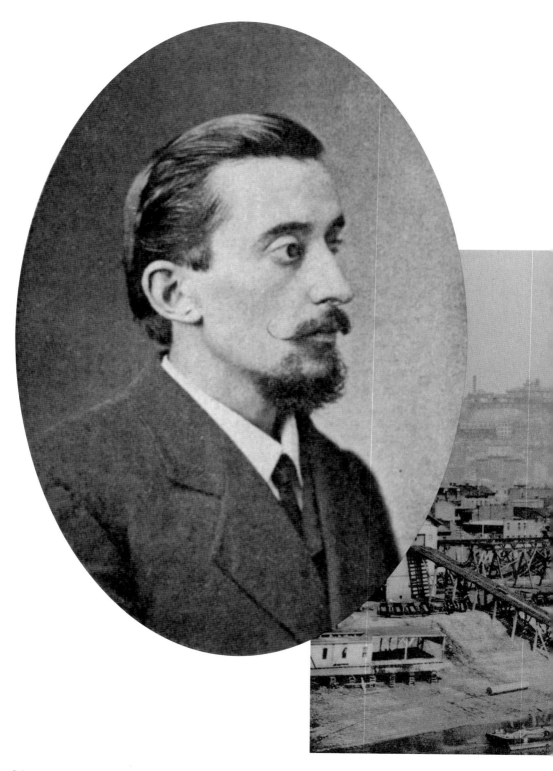

Lafcadio Hearn (LEFT)
Cincinnati's chronicler of the *demi-monde*, journalist Lafcadio Hearn sought out the lower classes of the city, captivated by the details of their lives, their loves, their crimes, and their passions. Hearn arrived in Cincinnati from Ireland in 1871, sleeping wherever he could find shelter and working at whatever labor he could obtain. After working as a messenger boy and proofreader, he landed with the *Cincinnati Enquirer* after showing editor John Cockerill a manuscript he had written. As a staff writer, his beat was the waterfront shanties and poor neighborhoods like Rat Row and Sausage Row—and the life along the river levee known as "Bucktown." The sordid doings of prostitutes, thieves, and flim-flam men made exciting copy for the newspaper, as did the ghost stories he uncovered. From Cincinnati, Hearn made his way to New Orleans and eventually to Japan, where today he is revered as a major literary figure.

Bucktown
In these squalid areas of the city, Hearn found the rich stories he craved from the Irish, African-American, and itinerant denizens who worked on the riverfront or did menial labor throughout the city.

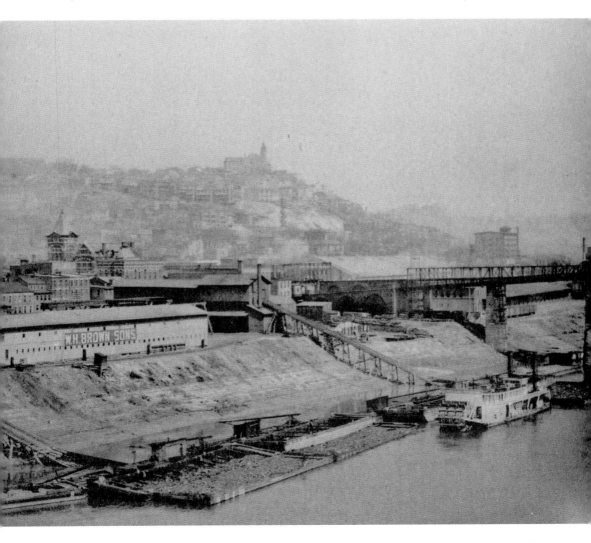

A.O. Russell

He was the founder of a worldwide brand, and his company would become the supplier of casinos everywhere, as well as the household bridge night and the firehouse euchre game. In 1867, A.O. Russell joined with three partners, including circus impresario John Robinson, to form a printing company. Moving from circus posters and circulars, Russell's firm grew, and after he brought in other printing companies under his direction, his business became the United States Playing Card Company in 1894. The brand names "Bicycle," "Bike," and "Bee," along with specialty names, made U.S. Playing Card world famous. As late as the 1970s, a potential graduate student from Japan applied to the University of Cincinnati, wanting to see "the city that makes the playing cards."

Louis and Regina Graeter

Louis Graeter began his ice-cream business in Cincinnati, but in the late 1860s he had a fair measure of wanderlust and left Ohio to head west to California. His brother Fred was left to tend to the business. But after returning to the Queen City in 1900, Louis married for the third time, on this occasion to Regina Berger, who was more than two decades younger than him. At his death in 1919, she assumed control of the business, making Graeter's ice cream an iconic Cincinnati product.

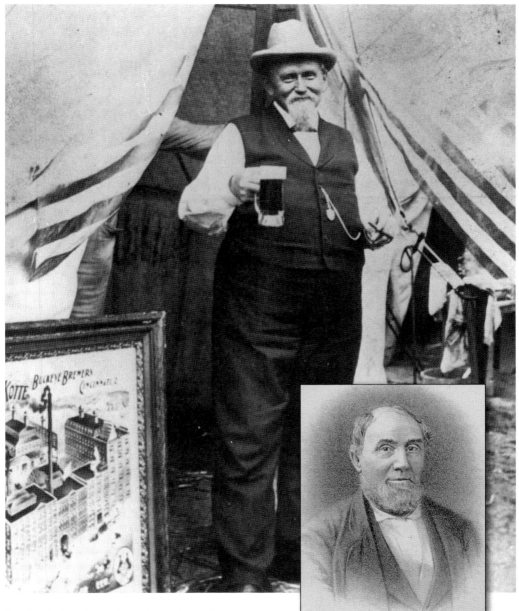

Louis Hudepohl and Louis Hudepohl II

The elder Hudepohl (inset) was a wholesale liquor merchant in business with George H. Kotte. When his father died, the younger Hudepohl convinced Kotte that they should sell the business and buy the Buckeye Brewery. By 1885, "Hudepohl" meant "beer" in Cincinnati. Hudy II eventually bought out Kotte, and by the mid-1890s, his brewery was producing 100,000 barrels each year. That was the business part of the Hudepohl life. The social part was just as important. The brewery often held picnics for its workers where the beer and song flowed freely. Louis Hudepohl II loved singing societies and was active in the *Saengerfest*. He was also a member of a comedy singing trio, Hudly, Midfort, and Shipley Co., who provided entertainment at festivals.

Samuel F. Hunt

Born in 1844, Samuel Furman Hunt came to Ohio to study at Miami University, but completed his degree at Union College in Schenectady, New York, in 1864. During the Civil War, he tended to the wounded at the Battle of Shiloh and helped organize the Ohio 83rd Regiment. Following the war, he enrolled at the Cincinnati Law College, graduating in 1867 and beginning a legal career. His biggest civic influence came in education as he helped determine the philosophy and curriculum of education at the newly created University of Cincinnati in 1870, serving as chair of the board of directors from 1883 to 1889.

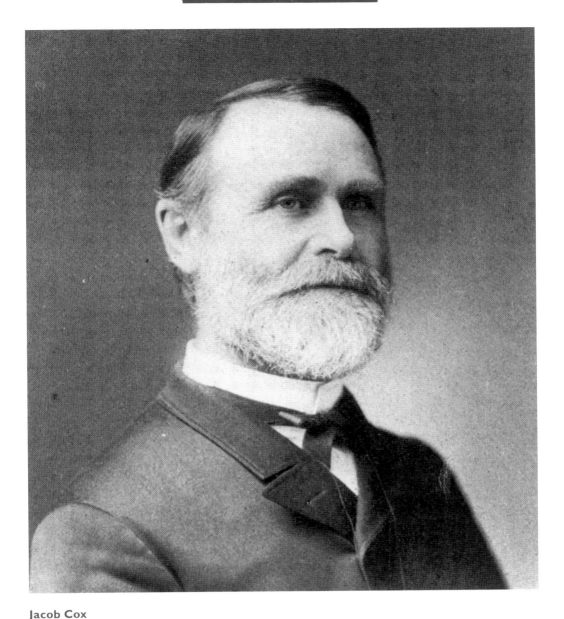

Jacob Cox

Jacob Cox had a vision for higher education in Cincinnati. An erstwhile Civil War hero, former Ohio governor and congressman, and member of Ulysses Grant's inner circle of advisors, Cox was appointed by the City of Cincinnati in 1888 to be president of its fledgling university. Though the University of Cincinnati (UC) now claims an origin date of 1819 to reflect its absorption of the original Cincinnati College, it was not founded as a university until 1870. Still in its infancy as a municipal university, UC had to come to terms with conflicting notions of what an urban higher education should be about. Cox's view was that a university should always serve—and be served by—the city in which it was located. Cox foresaw the merger and assimilation of several independent colleges in pharmacy, medicine, and dentistry under the University of Cincinnati's banner, the result being an effective institution whose mission was service, teaching, and research.

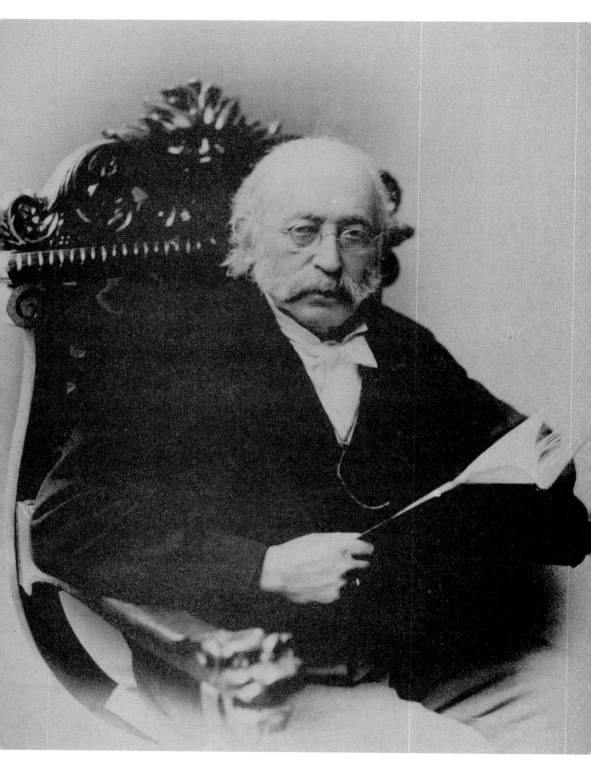

Isaac M. Wise (LEFT)

The father of Reform Judaism, Isaac Wise was born in Bohemia in 1819 and came to the United States in 1846. Establishing himself as a rabbi in America, however, was fraught with dissension and conflict. Wise found an American Jewish community frequently at odds about how to accommodate women and changes in prayers during synagogue services. Arriving in Cincinnati in 1854—following a stint in Albany that saw a theological divide in the Jewish community and a fistfight between Wise and the president of his synagogue—he became the rabbi of the Lodge Street Synagogue. In 1866, he was instrumental in building the Plum Street Temple, one of the most beautiful buildings in Cincinnati, and now called the Isaac M. Wise Temple. His lasting contribution to the American Jewish heritage is undoubtedly the establishment of the Hebrew Union College (HUC) in 1875, the premier institution of higher learning for the training and ordination of Reform rabbis.

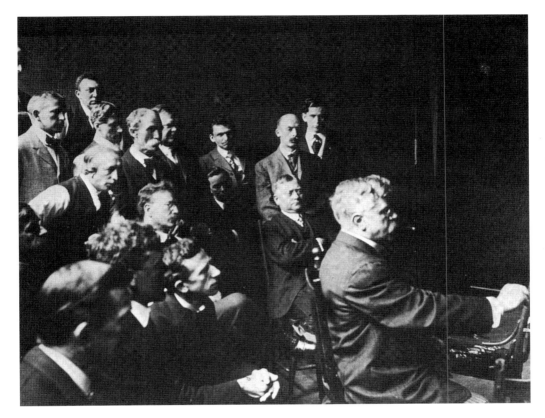

Frank Duveneck

One of the most prominent figures in Cincinnati's rich art history, Frank Duveneck was the son of German immigrants from across the Ohio River in Covington, Kentucky. His artistic talent demonstrated itself early in his teens in the 1860s, so he apprenticed under local German church decorators. In 1869, young Duveneck moved to Munich to further his studies at the Royal Academy, joining other young American painters who embraced a dark, heavy palette. By the late 1870s, Duveneck opened his own school in Munich. His students, such as Henry Twachtman, formed a group that became known in art circles as the "Duveneck Boys." After the tragic death of his wife, Elizabeth, from pneumonia, he returned to America and taught at the Art Academy of Cincinnati for many years. Duveneck is considered one of the premier artists of the early 20th century, and his work is prized by many museums, especially the Cincinnati Art Museum. He died in his hometown of Covington in 1919.

31

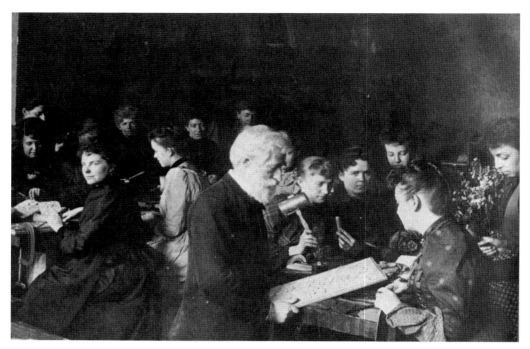

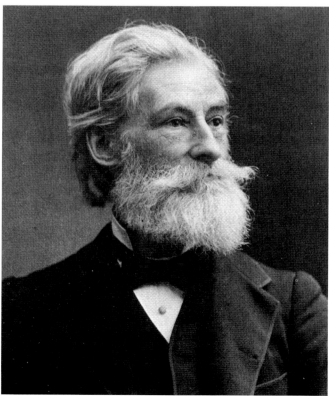

Benn Pitman
A native of England, Pitman came to Cincinnati in 1853 and eventually taught woodcarving at the McMicken School of Design, one of the first manifestations of what would become the University of Cincinnati. His classes in art-carved furniture, one of which is shown here, were coupled with numerous public lectures on the aesthetics of decorative art. Though Pitman excelled at woodcarving, examples of which can still be seen in some Cincinnati homes, while in England, he was also expert at shorthand. His brother, Sir Isaac Pitman, had joined with him in a venture to create the Phonographic Institute to teach shorthand, and their method continued to be taught for decades.

Samuel Hannaford

He is Cincinnati's architect. No other person of pencil and drafting table has had such a long-lasting cultural influence on the city. Hannaford was born in England in 1835 and came to Cincinnati with his family when he was nine years old. Growing up in Cheviot, he obtained his architectural training through practical experience in an established firm. By the Civil War he was a professional architect himself, and in 1869 Cincinnatians saw his first major work, the Cincinnati Workhouse in the Camp Washington neighborhood. This city jail looked positively Dickensian, more of a fortress or penitentiary than a simple local jailhouse. With male and female wings, workshops, and a chapel, the workhouse spread over six acres. By the 1980s, it no longer housed prisoners, and the dank, deteriorated cells and hallways were used to store the record ledgers of municipal bureaucracies. It was finally demolished in the 1990s. Hannaford designed everything from private homes and churches to the magnificent Music Hall. At his death in 1911, Samuel Hannaford left a legacy of over 300 buildings in the Greater Cincinnati area that he had designed.

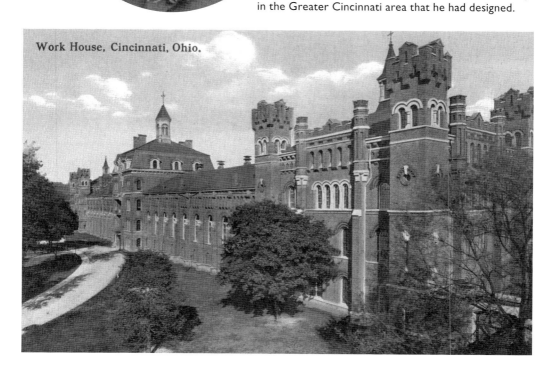

Work House, Cincinnati, Ohio.

33

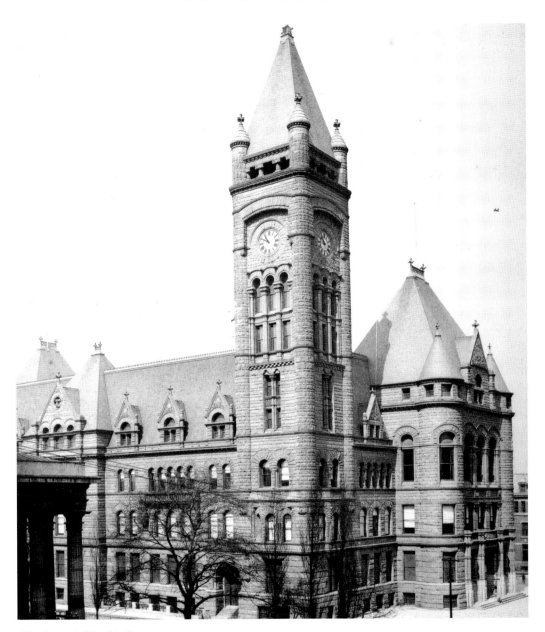

Cincinnati City Hall

Along with Music Hall, another of Hannaford's most enduring and beautiful buildings is Cincinnati's City Hall. Designed in the Romanesque style of H.H. Richardson's work, Hannaford's City Hall was begun after he won the design competition for it in 1887. A year later the cornerstone was laid, and after some design changes, the building opened in 1893 with fireworks and speeches. The massive stonework, the nine-story clock tower, and the Italian marble stairways all contributed to the city's sense of its municipal importance. Most remarkable of all, perhaps, are the stained-glass windows that portray the Roman soldier-farmer Cincinnatus and scenes showing Cincinnati's history of early settlement in the Northwest Territory.

CHAPTER TWO

Creating Cincinnati's Identity

With the number of immigrants changing the very nature of the city in the decades following the Civil War, Cincinnati struggled to accommodate the diverse nature of its population. German emigrants continued what was now a decades-long trek down the Ohio River to take up residence in Over-the-Rhine, the German neighborhood of the city that was bordered on its south edge by the Miami-Erie Canal and the hillsides to the north. There were stretches of saloons along Vine Street, elegant homes at the western edge, working class streets to the east and north. It was, perhaps, Cincinnati's most mixed-use neighborhood, with churches, factories, schools, and stores side by side. Italians and Eastern Europeans also came in numbers, settling into their own ethnic enclaves not only in sections of Over-the-Rhine, but in Fairmount, Price Hill, and Corryville as well.

There developed a considerable inclination on the part of cities everywhere to make effective changes in how they were governed, how streets were policed to reduce crime, how safe water and sewage would contribute to improved public health, and how school curricula were to be designed. This was the Progressive Era, in which there was hope that citizens could foster change if they bonded together in common purpose. One aspect of this was integrating emigrants into American life. So-called settlement houses were established to teach the English language, provide job training, teach hygiene, and offer standard education. One of these settlement houses was run by the University of Cincinnati faculty and students as part of their mission to serve the city. Another was created by the Santa Maria Institute for Italian children, yet another to answer the needs of Jewish immigrants, and the German *turnverein* functioned to maintain an awareness and appreciation of the homeland while contributing to civic service in the new land. It was the age of social service agencies and organizations, and the realization of what was possible.

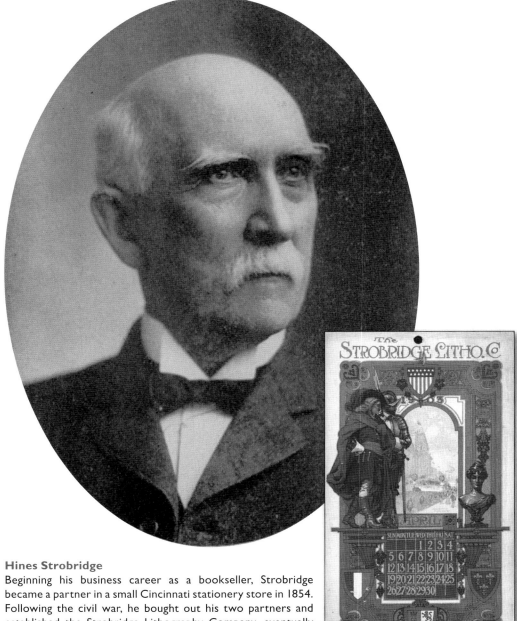

Hines Strobridge

Beginning his business career as a bookseller, Strobridge became a partner in a small Cincinnati stationery store in 1854. Following the civil war, he bought out his two partners and established the Strobridge Lithography Company, eventually building a factory in 1884 along the Miami-Erie Canal in Over-the-Rhine. The circus and theater posters he printed in Cincinnati spread the Strobridge name around the country, making the firm famous. Hines Strobridge hired lithographers, artists, and designers for the richly printed posters, also producing a monthly series of calendar cards. The cards subsequently became exemplars of art nouveau design. In the decades since the end of the Strobridge days, the cards and posters have become valuable additions to museum and library collections.

Rudolph Wurlitzer

His is the name behind the mighty pipe organs, first manufactured in Cincinnati. Franz Rudolph Wurlitzer established his firm in 1853, at first selling imported instruments until he developed the manufacturing arm of his company. By the 1880s, the Wurlitzer Company was building coin-operated pianos. The "Mighty Wurlitzer" was first introduced in 1910, and theaters and churches around the country installed them for choirs and performances. Later, the Wurlitzer business made jukeboxes and home electronic organs. Wurlitzer and his wife were known for their frequent home entertainments, providing sheet music for guests invited to play, and requiring everyone to sign a special autograph book. His three sons carried on the business in Cincinnati, the wife of one of them also carrying on the parties at home. Those galas became a bit odd, though, as she informed every guest on arrival exactly how many hors d'oeuvres and drinks each was allowed to have.

Jacob Hoffner

A wealthy real estate speculator who loved traveling in Europe, Hoffner would return to Cincinnati with ideas for the sculptural garden at his home in Northside. Two examples were the Italian lions he had seen in the Loggia del Lanzi in Florence. He had copies made for his garden, and when he died in 1894, he bequeathed his home and gardens, with all their statuary, to the city. The bequest would only take effect, however, after the death of his widow. His intent was that Cincinnati would create a park, which they did ten years later when Mrs. Hoffner died. The marble lions? The Park Board offered them to the city's university, the University of Cincinnati, and in 1904 they were placed at the entrance of old McMicken Hall. Dubbed "Mick" and "Mack," they still stand in front of the new (well, 1950) McMicken building facing Clifton Avenue.

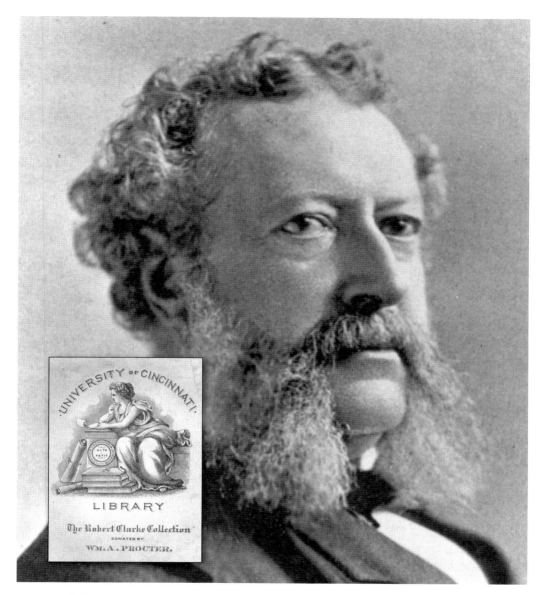

William A. Procter

The son of the Procter & Gamble cofounder, Procter established himself not only as a strong successor to his father in business, but as a civic leader as well. While sitting on the University of Cincinnati's Board of Directors in 1898, he took it upon himself to build the university library's collections with the anticipated opening of the new Van Wormer Library on the new campus in Burnet Woods. His first purchase was the private library of Cincinnati bookseller, publisher, and bibliophile Robert Clarke, known for his collection of books on Americana, world travel, and natural history. Clarke's 6,792 volumes formed the founding collection of the library, and after Procter donated it to UC, he set about to add the 1,420 books of the Enoch T. Carson Shakespearian Collection, and then the chemistry book collection of UC professor Thomas H. Norton. These gifts provided a fine start to what would become an excellent university library system of over 4 million books.

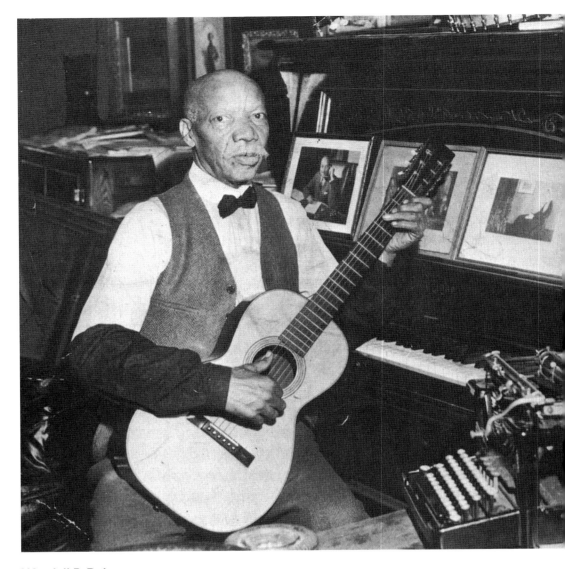

Wendell P. Dabney

A lifelong advocate for the rights of African Americans, Wendell Phillips Dabney used the power of journalism to push for equitable treatment. Born in Virginia to former slaves, Dabney briefly attended Oberlin College, but left to pursue a career as a musician. He was a prolific songwriter and played mandolin, violin, and banjo, and after coming to Cincinnati in 1894 on family business, he made the decision to remain and open a music studio. But his marriage in 1897 and his awareness of the condition of African Americans in Cincinnati convinced him that he needed a strong public voice. To fight for better race relations, he first published *The Ohio Enterprise*, and then *The Union* from 1902 to 1952. *The Union*'s masthead slogan was "No People Can Be Great Without Being United, For In Union There Is Strength," and Dabney lived that fully. A pamphleteer as well as a newspaper publisher, Dabney's writing found its most lasting expression in his book, *Cincinnati's Colored Citizens*, published in 1926 to extol the achievements of the local black community. Wendell Dabney also served as the first president of the Cincinnati chapter of the NAACP.

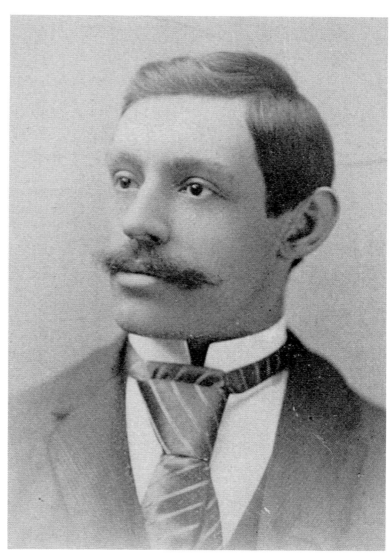

Barney Kroger

Born in 1860 and orphaned 13 years later, Barney Kroger made his own way in life. He became a partner in a grocery store after several years of selling tea and coffee door-to-door, and by 1886 had a small chain of four groceries. He decided to expand his operations, in each store offering shoppers the opportunity to buy meat and bread rather than going to separate shops. By buying in bulk, he was able to establish his own warehouses, and by 1893 Kroger's stores numbered 17 and were well on the way to becoming a national chain. But it was the year 1911 in which Kroger truly appreciated the good fortune he had made for himself. Walking about in downtown Cincinnati, he noticed many blind beggars on the street corners, destitute and without any hope for better lives. With Cincinnati philanthropist Frances Pollak and the backing of other concerned citizens, Kroger helped found the Cincinnati Association for the Blind to provide job training and education.

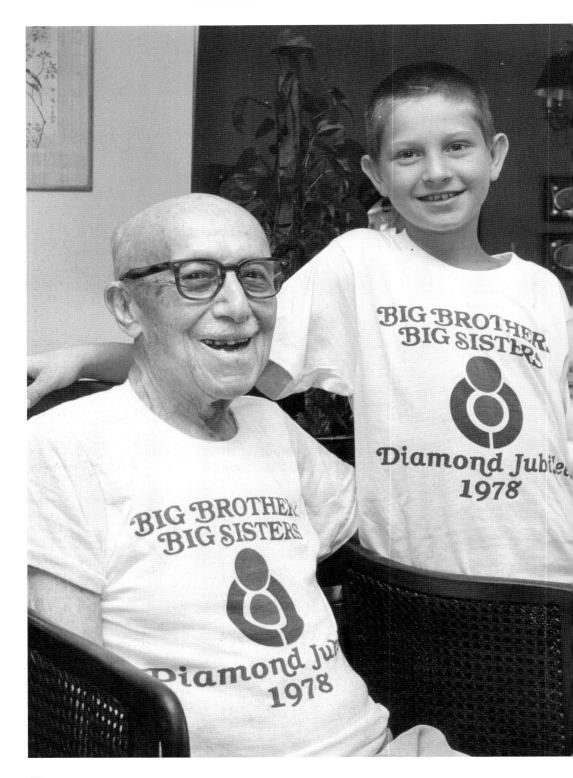

Irvin Westheimer (LEFT)

It all started one morning as a businessman was walking into his office to begin work for the day. In 1903 as he walked through the back door of his building, Irvin Westheimer spotted a small raggedy boy rifling through a garbage can, looking for any food scraps he could find. Westheimer had one of those moments of clarity that indicate the future path one must take. He recognized it as an opportunity to reach well beyond himself. Westheimer approached the boy, introduced himself, and began what became a friendship between the two. The boy was fatherless, and Westheimer saw the boy's need for an adult friend. Encouraging his colleagues and acquaintances, Irvin Westheimer began a movement that became the Big Brothers of America. Five years later, Mrs. Cornelius Vanderbilt would build upon Westheimer's initiative and form a big sisters program in New York. The Big Brothers/Big Sisters of America became a joint entity in 1997. Westheimer pursued a very long life of considerable philanthropy, reaching the age of 101 when he died in 1980.

Christian Moerlein

Immigrating from Germany in 1841, Moerlein made his way to Cincinnati, arriving the next year in 1842. He first found work as a blacksmith, learning English as he went, and in 1853 began a small brewery. By the 1890s, Moerlein's was the largest brewery in Cincinnati, extending its sales as far south as New Orleans. On his farm outside Cincinnati, Moerlein grew his own hops, and his massive brewery complex at the north edge of Over-the-Rhine on Elm Street was one of the largest structures in the city. The brewery had another, rather odd, function: for a brief time, it provided storage for the cadavers used by the nearby laboratories of UC's medical college, at that time located in the old University Building on the Clifton hill.

John Hauck

Another of Cincinnati's notable German-born brewers, John Hauck began his beer-making career in 1852 when he went to work for his uncle, George Herancourt, another early local brewer. After establishing his business, Hauck set about to fulfill another aim, of signing up neighborhood saloons as "tied houses," meaning that they would only sell Hauck beer. It was a common practice for brewers at the time. Hauck was an astute businessman, running the German National Bank for a time as well as his brewery. He served as the president of the Cincinnati Reds in 1866, and then came back to own the team in the 1890s after they were kicked out of the National League for selling beer and playing on Sunday. A charter member of the rival American Association, Hauck's team generated additional income with concessions, or as they were termed, "privileges," including, of course, Hauck beer. Baseball beer sales became a steady source of income for the brewery.

Julius Fleischmann
Fleischmann was the heir to a yeast and gin fortune in Cincinnati, but found his greatest expression in politics. He was elected as a Republican mayor of the city from 1900 to 1905 and was a key figure in Boss George Cox's machine. Even so, Fleischmann had reform sensibilities and was able to mediate between different political and civic factions. As the years inched toward Prohibition in 1920, Fleischmann tried to galvanize a cooperative effort among Ohio's brewers and distillers, but it was of little avail. Despite his political skills, he could not convince them to take action to save their businesses by keeping Prohibition from becoming law.

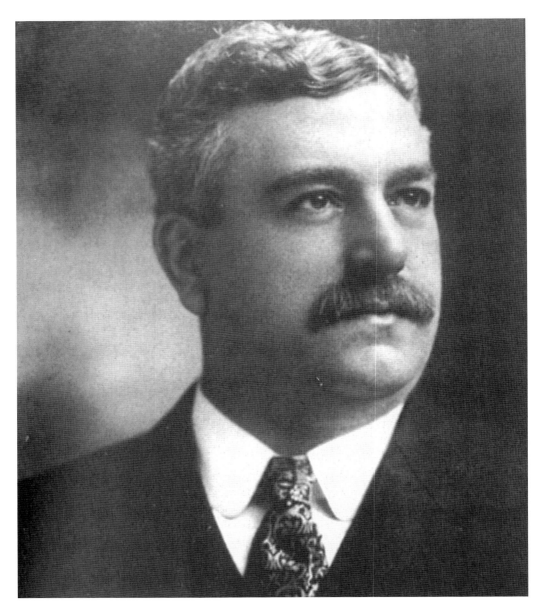

George B. Cox
He was the Boss of Cincinnati, the man who pulled the political strings behind the scenes. From the 1880s through the early 1900s, George Cox headed machine politics in the city, doling out patronage jobs and backing the candidates in the Republican Party. His word was often law, and from his "office" in the Mecca Saloon, Cox determined who would run for which office. His organization was rife with graft, but to many citizens, he was a man who got things done. The election of reform mayor Henry Hunt in 1911 led to the decline in Cox's political power, and he died in 1916. If there were fond memories of him, however, they may be of his role as a partner with Max and Julius Fleischmann, Garry Herrmann, and minor investors, who bought the Cincinnati Reds in 1902 from Indianapolis department store owner John Brush, thus bringing back local ownership of the hometown team.

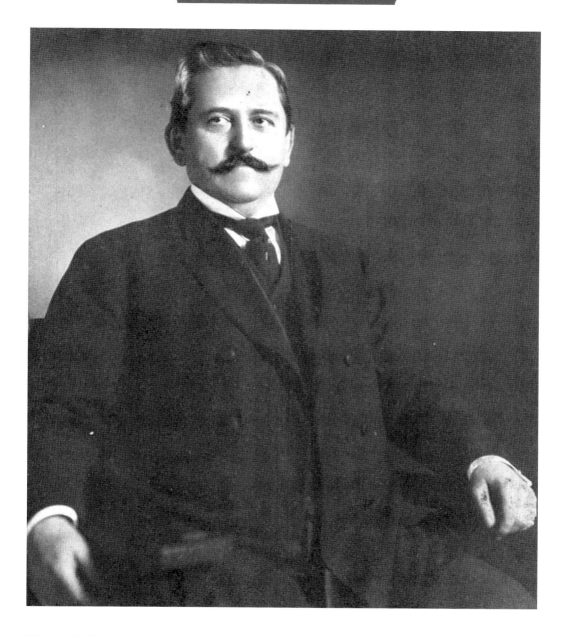

Charles Dabney

An educator who believed Cincinnati's municipal university must always be a vital part of the city, Charles Dabney became president of the University of Cincinnati in 1904, a position he held until 1920. Dabney came to Cincinnati from the University of Tennessee, where he expounded on the idea first articulated by Jacob Cox that colleges and universities exist to serve their communities. In turn, he believed communities had an obligation to provide sufficient funds for their schools and to partner with them on terms of mutual benefit. Early on, Dabney was at odds with George Cox on funding sources for UC, but his strong, no-holds-barred approach impressed Cox, who gave in to Dabney's insistence on equitable financial treatment for the university.

Edward Miles Brown (RIGHT)
The epitome of the dedicated teacher, Brown may be completely unknown today, but when he taught at the University of Cincinnati from 1891 to 1907 he was revered by his students and colleagues. Much of this reverence was due to the passion he brought to the classroom when he recited poetry and extolled the beauties of literature. But a large measure was testament as well to the downright courage of the man. Brown was born in Michigan and pursued his undergraduate studies at the University of Michigan. Following some years as a high school principal in Indiana, he moved with his wife to Germany, where he earned his doctoral degree. Brown returned to America and a brief stint at Cornell in 1890. His subsequent appointment in the English Department at UC not only included teaching, but editing the university's publications as well. But he was soon struck with painful rheumatism, and in the last years of his teaching, he was confined to a wheelchair, barely able to hold a pencil in his hand. Still, he made it to every class, every day. His students would lift his wheelchair onto the dais of the classroom and then see him safely back to his office. In 1907, he retired to his home state of Michigan, leaving to his students this quote from Mark Twain that they included in a memorial at his death a year later: "Affection is the most precious reward a man can desire, whether for character or achievement."

Herman Schneider
The first to introduce cooperative education in American universities, Schneider benefitted from Charles Dabney's emphasis on service. As dean of the College of Engineering, Schneider developed his co-op program by placing his students in local industry and commercial business, with the idea that practical training coupled with classroom instruction would make them valuable and innovative employees—and citizens. Schneider insisted that part of every school day be set aside so students could pursue anything but engineering. The college had its own art gallery, began what became the UC marching band, and its students contributed widely to campus publications. A well-rounded student, Schneider believed, became a contributing member of society.

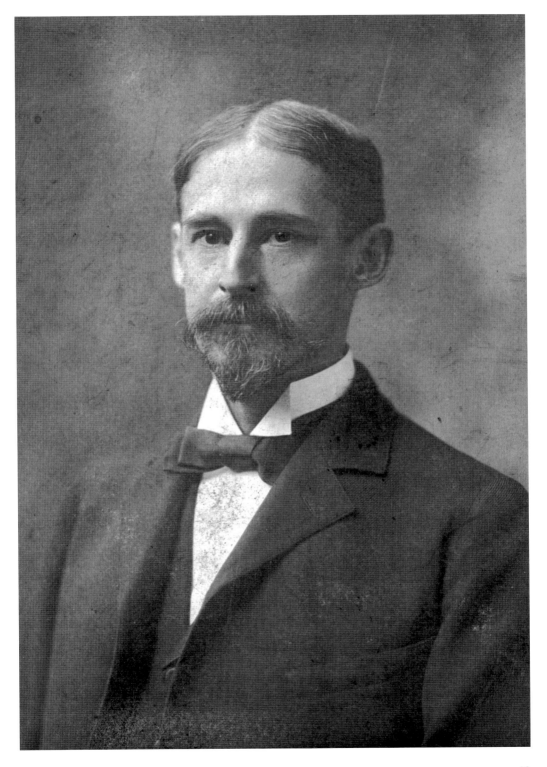

Otto Juettner

Arriving from Germany in 1881, Juettner pursued his education with a bachelor's degree from Xavier University in 1885, followed by a degree from the Medical College of Ohio in 1888. Juettner held several medical and teaching appointments in the city for the next three decades, but it was his gift for music and history that makes him notable. His monumental history of medicine in Cincinnati, *Daniel Drake and His Followers*, was published in 1909, and he composed many college songbook tunes, including the alma mater for the University of Cincinnati. For his own undergraduate alma mater, he wrote the fight song "Xavier for Aye": "Sing the song, and sing it loud and long. Let it be our pledge today, Our Alma Mater proud and strong, Old Xavier for Aye!"

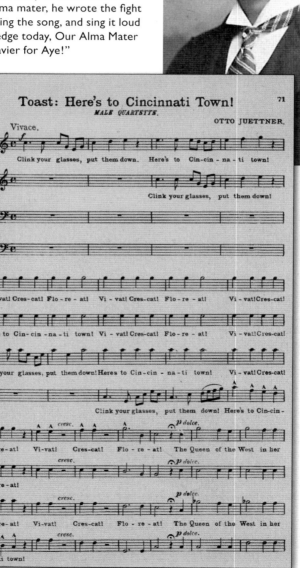

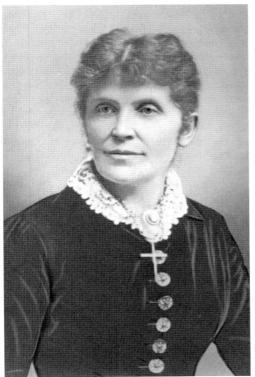

Clara (LEFT) **and Bertha Baur**
In 1867, Clara Baur founded the Cincinnati Conservatory of Music. The German-born Baur arrived in the city in the 1850s to visit her brother and decided to stay. When she started her school in a set of rented rooms, her goal was to provide advanced training in singing and instrument mastery, and to that end, she hired the best teachers she could land. Less than a decade later, the College of Music would also be created, and together the two schools offered some of the best conservatory training in the nation. While both boasted faculty trained in Europe and in the eastern United States, the Conservatory tended to attract more female and Southern students while the College enrolled more students from the East. Baur began her school downtown, as did the College of Music, but at the turn of the 20th century she moved it to the old Shillito mansion on Highland and Oak Streets in Walnut Hills. When she died in 1912, her niece, Bertha, took over leadership, a position she was eminently qualified for as she had assisted her aunt for years. In 1955, the Conservatory and the College merged to form the College-Conservatory of Music, and in 1962 it was brought into the college structure of the University of Cincinnati.

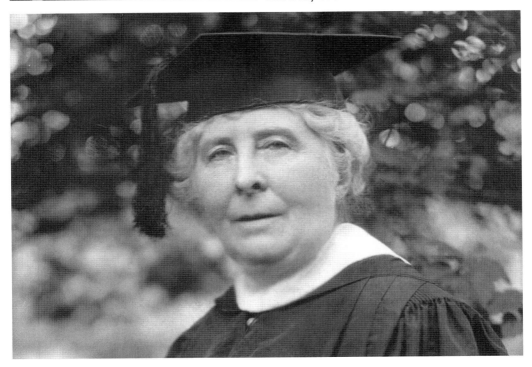

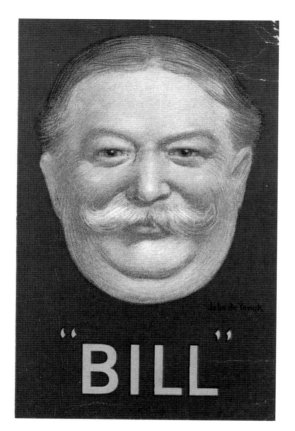

"BILL"

William Howard Taft

Given his family background and his own legal and political appointments, it seemed that William Howard Taft's run for the presidency was a foregone conclusion. In truth, he would rather have stuck with a career as a jurist and legal scholar, because he was happiest in those endeavors. But with pressure brought by his wife and by Theodore Roosevelt and other Republicans, Taft entered the race, and won in 1908. It wasn't always a happy time for him in Washington. Always fat, his weight ballooned when he was unhappy. At the end of his term, he left the White House and told a friend some time later that he was relieved to escape the pressure of the presidency. The proof was that he could button his own trousers without the aid of a valet. Despite his heaviness, Taft was an active man, playing golf regularly (he yelled at the ball) and riding horses. His true enjoyment came when he was named Chief Justice of the Supreme Court in 1921, where he served until his death in 1930.

A Message from the Skies!

Taft-Taft-Taft

"For the Honor and Glory of Cincinnati"

CINCINNATI, JULY 28TH, 1908

12

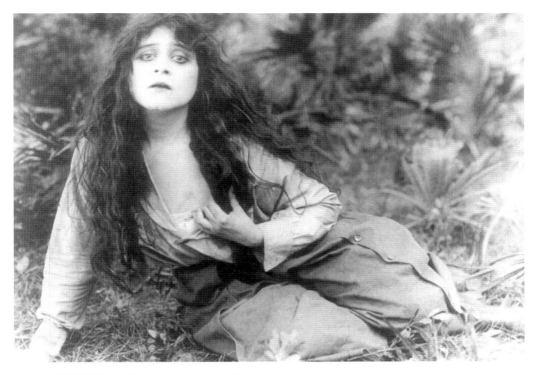

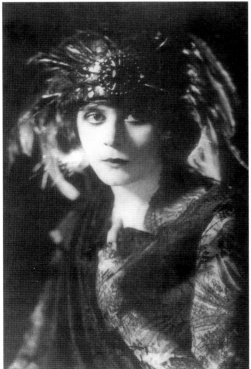

Theda Bara

Her lasting signature line in cinematic history is "Kiss me, my fool," from her silent film, *A Fool There Was,* produced in 1914. Publicists and journalists had a field day with the smoldering sexuality of Theda Bara. Born Theodosia Goodman in 1885, Bara attended Walnut Hills High School and then the University of Cincinnati for two years before moving to New York to pursue stage and film. Her image as a vamp, complete with a backstory of being the wayward child of an Arabian princess and an Italian painter, was all contrived, created by the film studios to attract controversy—and filmgoers. It worked. Theda Bara attracted thousands and thousands of fans over her career in the silents. And even though she maintained those "mysterious" romantic aspects of her film career in her ghostwritten autobiography, Bara led a quiet life during her career and in her retirement. After both she and the film industry relocated to Hollywood, she still made trips home to Cincinnati and maintained a house in Walnut Hills. The originator of celluloid's standard woman of domestic destruction, Bara died in 1955.

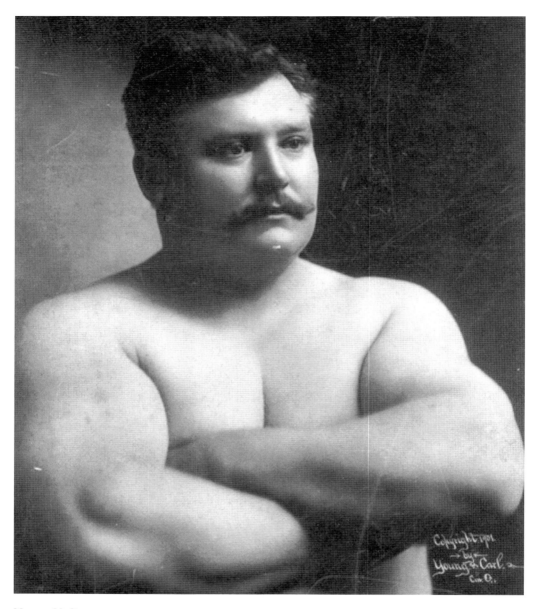

Henry Holtgrewe
Known in the early 1900s as the "Cincinnati Strongman," Holtgrewe was a legend in Over-the-Rhine where he worked as a saloonkeeper. While he would occasionally perform in vaudeville shows and circuses demonstrating his immense strength, most days and nights he could be found in one of the several neighborhood bars he managed. One of his favorite acts for his customers was to hoist two full beer barrels to his shoulders. Another time, he ripped a barbell from the sidewalk where it had been cemented as a promotion by a store owner. His most famous feat came in 1904 when he entered the Palace of the Fans, the West End ballpark of the Cincinnati Reds, marched to a wooden platform resting on braces, eyed the Reds ballplayers seated on it, crawled underneath, and lifted the combined 4,000 pounds on his back.

August "Garry" Herrmann

Escaping the political scandal that accompanied the machinations of his boss, George Cox, Garry Herrmann was a colorful, engaging figure in Cincinnati, a rotund aficionado of eating, parties, and baseball. He once proclaimed that he was the champion beer drinker and sausage eater in Cincinnati, and he probably was. Herrmann was born in 1859, and orphaned at an early age by the death of his father. He became the sole support for his mother and sister, scrambling to do odd jobs and finally becoming a printer's devil, or apprentice. From that position, Herrmann became involved in Cox's ward politics, eventually becoming the boss's right hand man in city government. The press loved him because he was always good for a quote, and the German American community reveled in his presence at picnics and beer gardens. After he joined with Cox and the Fleischmann brothers to purchase the Reds in 1902, Herrmann was named the team president, a post he held for the next quarter-century. A sporting man above all, Herrmann became involved in horse racing, bowling, the German Turner quadrennial *turnfest*, and even a bid for an early professional football team. He made an early attempt at having night baseball games in 1909, and a decade later was still the Reds president when they won the infamous 1919 World Series over the Chicago White Sox. His lavish eating eventually led to poor health and his death in 1931.

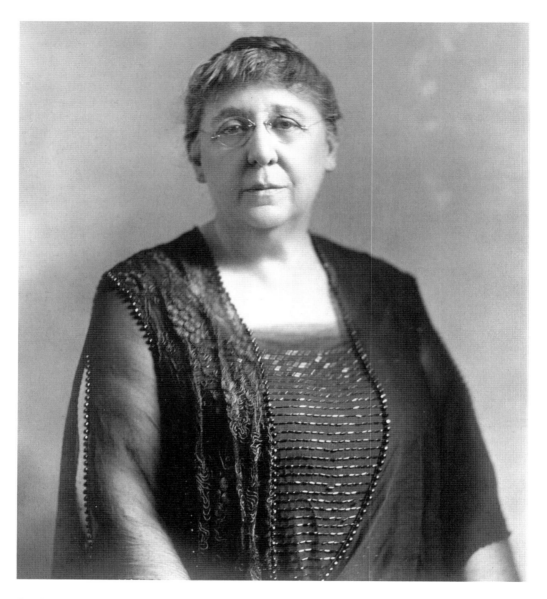

Annie Laws

Strong-willed and physically imposing, Annie Laws was a commanding presence, whether it was in classrooms, boardrooms, or behind the podium at conferences and meetings. She believed that women should be educated and be of service, and that society needed them in every facet of life. From the 1880s to her death in 1927, she never wavered in her development of opportunities for women. It was Annie Laws who helped found the Cincinnati Women's Club in 1894 to tackle civic problems, Laws who built the Cincinnati Training School for Nurses that eventually became the University of Cincinnati College of Nursing, and Laws who took a lead in the local kindergarten movement, ultimately combining it with other teacher-training programs to form what is today the College of Education, Criminal Justice, and Human Services at UC. Annie Laws argued passionately throughout her life in the belief that a unified group of people could always change public policy for the better.

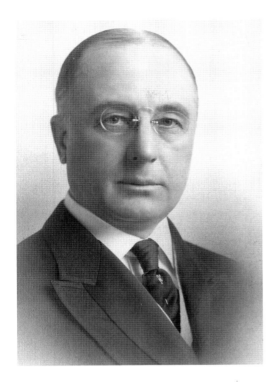

Christian Holmes

In 1894, a young Christian Holmes was appointed as a clinical professor of otology in the Miami Medical College, one of several predecessor schools of the current College of Medicine at the University of Cincinnati. After the 1909 merger of the Miami Medical College with UC, Holmes continued as a professor until 1919, and for a time during those years, served as dean of the school as well. His noteworthy achievement came outside the clinical field: Holmes was appointed to establish a modern general hospital for the city where the staff would also be appointed as faculty in the college. His vision for the hospital, built up the hill from the old hospital along the canal downtown, involved airy pavilions and walkways. He believed such an environment would be conducive to patient recovery, while at the same time providing a campus environment for the staff. Holmes's vision was made real with Cincinnati General Hospital. He died in 1920, and in his memory the Fleischmann family donated the funds to build Holmes Hospital, an auxiliary institution next to the main hospital.

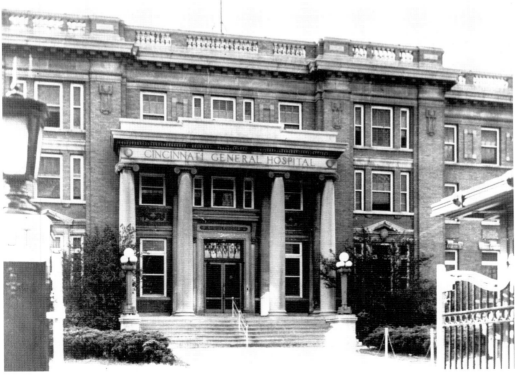

H.H. Fick

Because of the ethnicity of a large portion of its population, Cincinnati's public schools had a considerable element of German influence in its curriculum. It was the leadership of the German Turners that fostered physical education in the school, and it was educators like H.H. Fick who promoted German language and literature. Until World War I, and a period of anti-German sentiment, Fick served as superintendent of German instruction for the school board. A respected historian, poet, and essayist on German American heritage, his extensive personal library eventually formed the core of the German-Americana Collection in the University of Cincinnati Libraries.

Heinrich A. Ratterman

Ratterman was a contemporary of Fick's and a major poet in his own right. Ratterman documented the German American experience primarily through his journal, *Der Deutsch Pionier*, and composed several hundred poems extolling the contributions of German culture in the United States.

CHAPTER THREE

Cincinnati
Ebbs and Rolls

In the years leading up to World War I, Cincinnati was still reaping the changes brought about by Progressive Era activism. Playgrounds were built in the city, as well as community centers to bring children under safe observation and remove them from the negative influence of the streets. The years of control by the Cox political machine were drawing to a close, and housing problems for the poor were being addressed. But on the horizon trouble loomed. With the growing threat of war in Europe, and the United States finally entering the conflict, anti-German sentiment began to grow. Long part of American life, especially in a city like Cincinnati, Germans were regarded with increasing suspicion. German books were removed from the public library. German street names were changed to English ones. German language instruction in the public schools was discontinued. The growing approval of Prohibition also reflected this ethnic strife. As most brewers by this time were of German heritage, enacting Prohibition, which finally happened in 1920, seemed almost patriotic.

But those years also were filled with excitement and joy over the arts in Cincinnati, with the Gorno brothers at the College of Music and concerts at Music Hall drawing crowds. The era brought Cincinnati along in a rush to the Golden Age of American sports, with boxing becoming a major sport in the city, a homegrown Olympian competing on the international stage, and college sports at Xavier University and the University of Cincinnati attracting large numbers of loyal alumni.

Jacob G. Schmidlapp
The son of German immigrants who settled in Piqua, Ohio, Schmidlapp overcame a childhood of poverty to become one of Cincinnati's leading citizens and philanthropists in the early 1900s. He founded the Union Savings Bank and Trust in 1876 and with his business investments became a very wealthy man. But as so many prominent citizens did in an age referred to as the "Progressive Era" in America, Schmidlapp looked beyond his own riches to the city streets he walked every day. There was a great need for improved urban hygiene, for reduction in crime and corrupt politics, and for improved housing and education. Knowing full well that clean affordable housing for the poor could reduce crime, he joined with several partners to form the Cincinnati Model Homes Project to provide housing developments for those in need. And, one of the first established independent foundations in Ohio was of Jacob Schmidlapp's making. In 1908, his treasured daughter, Charlotte, was killed in an automobile accident while in France. In her memory, he created the Charlotte R. Schmidlapp Fund to answer the needs of women and girls in health and education. Schmidlapp continued his work with housing and local grants for the rest of his life. In World War I, he was called to serve the national effort in economic development, and shortly after the war ended, in 1919, Jacob Schmidlapp died. His bank merged with Fifth Third Bank of Cincinnati, which still continues his fund work through Fifth Third Bancorp.

Murray Seasongood (RIGHT)
Reform politics seemed to be a constant in 20th-century Cincinnati. The face behind much of it was Murray Seasongood. Born in 1878, Seasongood saw firsthand how machine politics worked. As a member of the Cincinnatus Association, he gave a fiery speech in 1923 that declared war on the political henchmen running affairs in city hall. He was elected as mayor on a reform ticket in 1926, and his first measures were to end the boondoggle that was Cincinnati's subway project and roust the ward heelers still in place from the Cox era. He also instituted the city manager form of government. Seasongood's career as a lawyer always kept him in step with Cincinnati watchdog politics. If his opponents figured he would go away, they were in for a long wait: Seasongood lived to be 104 years old, dying in 1983.

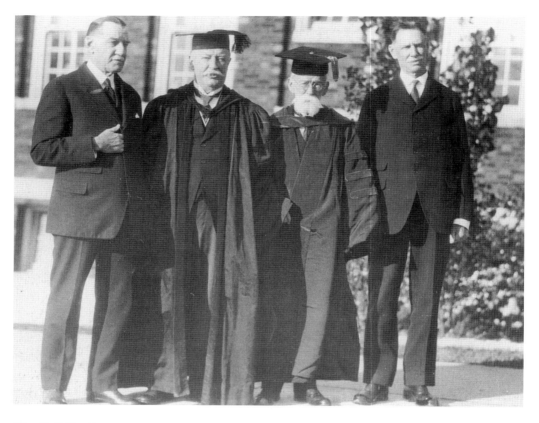

The Taft Brothers
It is difficult to underestimate the influence the Taft family has had on Cincinnati art, journalism, politics, and education over the past 150 years. Alphonso Taft was a powerful figure in civic affairs, and his sons continued the family tradition. Because of the elder Taft's leadership in Cincinnati's legal community, the University of Cincinnati named its College of Law building after him in a 1925 ceremony. William Howard Taft, a former dean of the college, President of the United States from 1909 to 1913, and the sitting Chief Justice of the Supreme Court, was given an honorary degree as he delivered the dedication speech. Brothers Henry (left), an attorney, Charles Phelps (second from right), publisher of the *Cincinnati Times-Star,* and Horace (right), headmaster of the Taft School, joined their jurist brother for the celebration.

The Gorno Brothers (RIGHT)
No less prominent in their own way were the remarkable Gorno brothers of the Cincinnati College of Music. Shown here as young weightlifters in their native Italy (from left to right, Albino, Romeo, and Giacinto), the brothers came to the United States on the heels of one another. The first was Albino, who came to the college in 1882. He performed as the pianist for Italian diva Adelina Patti in her 1883 American tour, and afterward set about to bring his brothers to Cincinnati. Romeo and Giacinto were soon here, and for the next 50 years provided music education and no small enjoyment of life. The trio of siblings laughed as much as they sang and performed, and they were all beloved by their students. Romeo invariably arrived somewhat late for the private lessons he gave, and would often swoop up the student on his back and carry his charge to a rehearsal room. His life came to a sudden and sad end one day when he was rushing to meet a student. Running across the street, he was struck by a car. His death left the city bereft of a fabulous teacher.

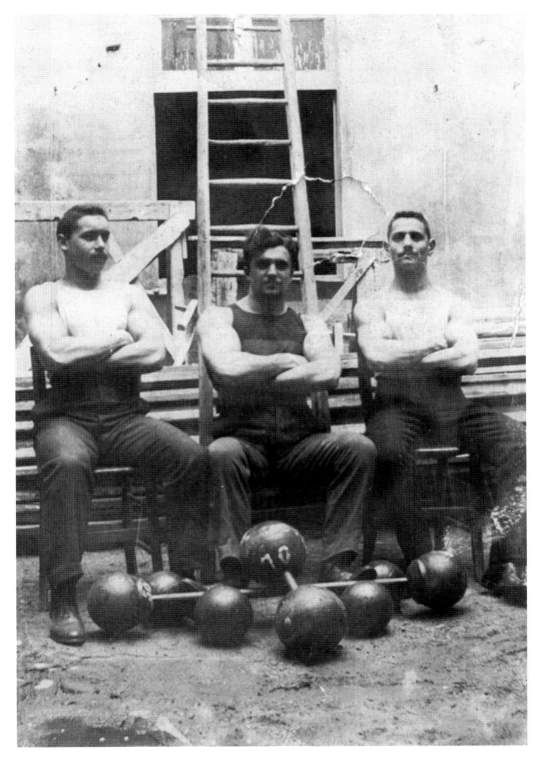

Mary Emery

She was called "Lady Bountiful" by Cincinnatians because of her philanthropic generosity and her dream of providing a planned village for the working class. Born in Brooklyn in 1844, Emery came to Cincinnati with her family in the midst of the Civil War in 1862. Marrying Thomas Emery in 1866, Mary lived a life of wealth and privilege with the fortune her husband had built through real estate investments. After Thomas's death from pneumonia during a trip to Egypt in 1906, Mary Emery became a benefactor for hospitals, orphanages, and schools. She provided the funds for the construction of a new building for the Ohio Mechanics Institute at Walnut Street and Central Parkway in 1908, including an adjacent auditorium named for her that had the purest acoustics of any concert hall of its time. In 1923, she underwrote the construction of Mariemont, a planned community named for her estate in Rhode Island. She is pictured at the village's dedication, four years before she died in 1927.

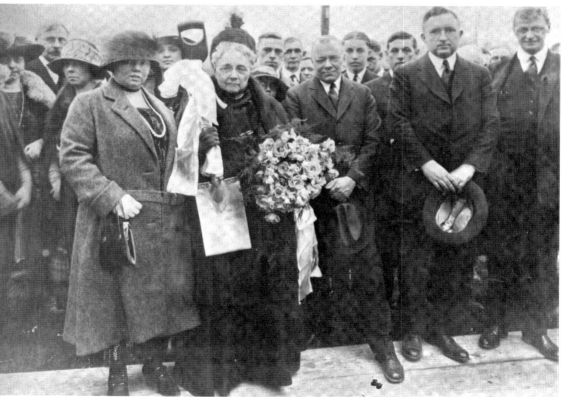

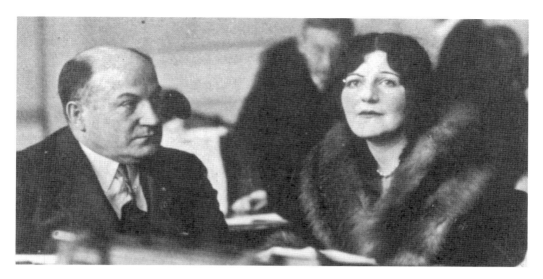

George Remus

Cincinnati can lay claim to one of the nation's biggest bootleggers during the years of Prohibition in the 1920s. While manufacturing and selling illicit liquor, George Remus amassed a fortune and pursued a lavish lifestyle on the west side of Cincinnati. The feds finally caught up to him, sending him to the Atlanta Penitentiary. While he was serving time, his wife tried to divorce him. On his release, he returned to Cincinnati, chased her down in Eden Park, and shot her to death. Successfully pleading temporary insanity, he was remanded to a state hospital for the criminally insane.

Anna Marie Hahn

On the other hand, murder was a regular business for Anna Marie Hahn. The German-born blonde temptress needed a way to fund a serious addiction to gambling on horses. She would ingratiate herself with elderly German gentlemen in Cincinnati, gain access to their bank accounts, and then poison them with arsenic. Caught after six victims died and one survived, Hahn's day in court led to her conviction and a death sentence. In 1939, she became the first woman executed in Ohio's electric chair. As journalist Ellis Rawnsley reminisced years later about the trial, "Seven victims of Anna Marie Hahn's were in court—six in pickling jars and one in a blue serge suit." Her final mark, George Heiss, survived to testify against her.

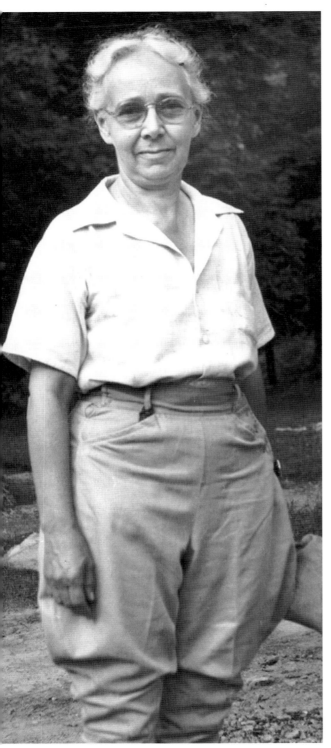

Lucy Braun

Her sister Annette may have earned the first PhD for a woman at the University of Cincinnati in 1911, but Lucy Braun eclipsed her in their careers. A greatly respected botanist, she earned accolades from the scientific community for her work on ecology, as Annette became her lifelong assistant. Lucy and Annette shared an interesting relationship: As children, Lucy was the favored child and was always dressed in pink while Annette wore blue. Lucy died in 1971, and when Annette died seven years after her younger sister, she made sure that she went to her grave clothed in a pink dress.

Jennie Davis Porter

The first African American woman to earn a PhD from the University of Cincinnati, Jennie Davis Porter was a remarkable teacher and school administrator. As principal of the Harriet Beecher Stowe School in the city's West End, Porter advocated segregation as a learning medium. Even in 1928, the year her dissertation was completed, her views were seen as running counter to full educational civil rights. Decades later, the developing trend of special charter schools freshly explored her ideas on how to best teach students of diverse backgrounds.

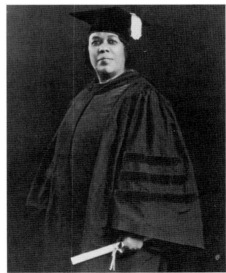

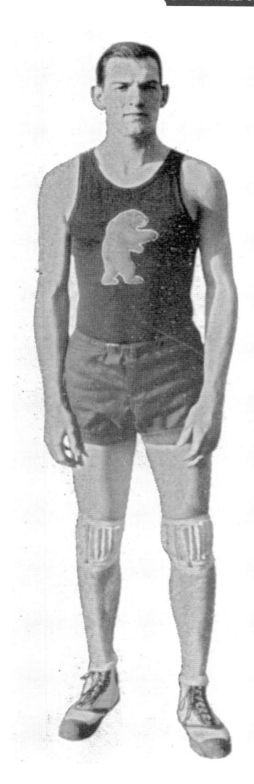

Ethan Allen

He was nicknamed by his Bearcat classmates as the "Dark-Haired Apollo" because of his striking good looks and his god-like performances on field and court. Ethan Allen was a star athlete in basketball, track, and baseball at the University of Cincinnati from 1924 to 1926. Because he ran track and played baseball in the spring, on some days he would play outfield for the baseball team, then strip down and hustle over to join his track teammates for a meet. He signed with the Reds in 1926, and had a very good Major League career for 13 seasons.

William DeHart Hubbard

A Cincinnati sports legend, DeHart Hubbard went from Walnut Hills High School to the University of Michigan, and from there to the 1924 Olympic Games in Paris. Competing in the broad jump, Hubbard became the first African American to win a gold medal at an Olympiad. Following his return home to Cincinnati, Hubbard formed traveling basketball teams and became a prominent figure in local recreation as he trained homegrown athletes.

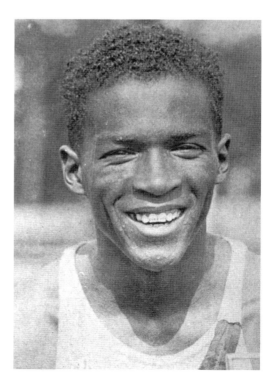

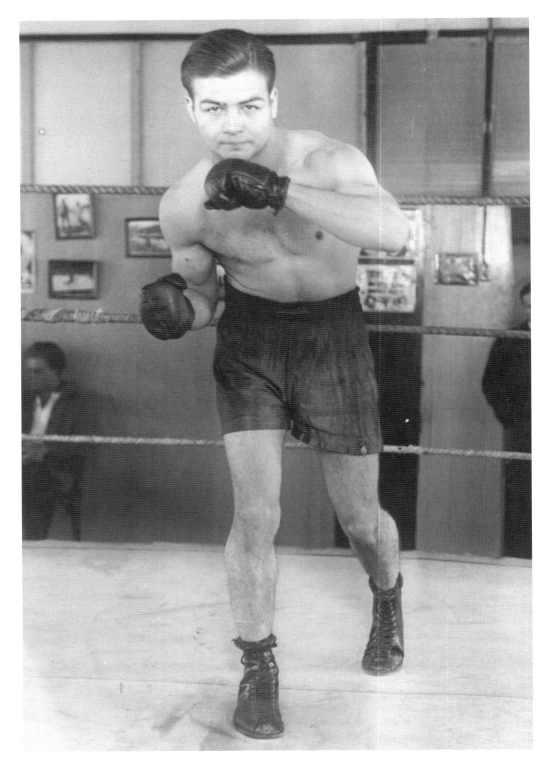

Freddie Miller (LEFT)

The first of Cincinnati's boxing champions, Freddie Miller was of German American stock from the city's Over-the-Rhine neighborhood. The first bout for the featherweight lefty was in 1927 when he was only 16 years old, a knockout victory across the river in a Fort Thomas hall. A neighborhood legend, Miller quickly became known for his perfect form in the ring. As he rose in the professional ranks, other fighters avoided him because he was a southpaw and difficult to fight. The result is that he would often pose for photos as a right-hander. Freddie Miller won the featherweight crown in 1933, and subsequently boxed in over 30 different countries, at one time becoming the toast of Belgian and Spanish ring life. And in his later years, he was known as a gifted dancer and bridge player. Eventually, though, the toll of 237 fights took its measure. Miller began suffering blackouts, and in 1962 he died from a blood clot in his brain.

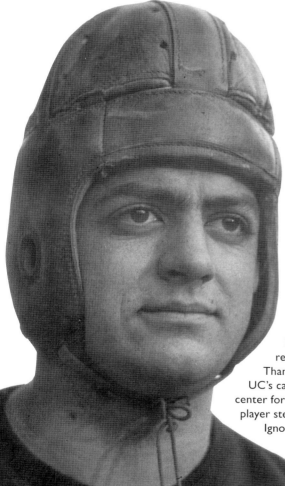

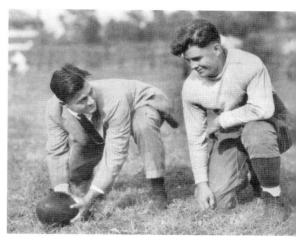

Jimmy Nippert

The story of Jimmy Nippert is the stuff college legends are made of. Handsome, accomplished, a scion of the Procter & Gamble fortune, Nippert was an outstanding football player for the University of Cincinnati in the early 1920s (shown top with his brother and teammate Louis). At that time, UC and Miami University renewed their football rivalry each year with a Thanksgiving Day game. The 1923 game was fought on UC's campus in a muddy, sloppy, rainy mess. Jimmy played center for the Bearcats and during the third quarter, a Miami player stepped on his leg, his cleats opening a deep wound. Ignoring his injury, Nippert finished the game, a 23-0 UC victory. In the days that followed, however, he developed a serious infection and was hospitalized. On Christmas morning, delirious and semi-conscious, Jimmy Nippert uttered the final words he had spoken to his teammates during the game, "Five more yards to go, then drop," and then he died.

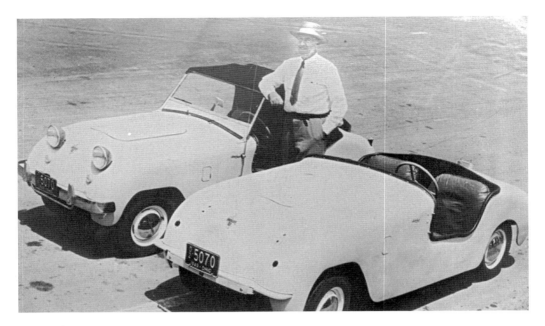

Powel Crosley

A dropout from law school, Powel Crosley had a mind full of ideas for the everyday American. Though he is best remembered for his ownership of the Cincinnati Reds from 1934 to 1961, Crosley developed a compact, low-cost automobile (called the "Crosley" of course), appliances like the "Shelvador" refrigerator, and radios, the latter a logical product for him given that Crosley also founded WLW Radio, during his lifetime one of the most powerful broadcast stations in America.

Joseph Strauss

Joseph Strauss graduated from the University of Cincinnati in 1895, just before it moved from its building on the hillside where Charles McMicken had lived to the Burnet Woods campus in Clifton. As an engineer, he designed bridges around the country; his senior thesis even posited a bridge across the Bering Strait. Strauss's crowning glory was his commission for the Golden Gate Bridge in San Francisco. In 1935 when he learned that the original building of his alma mater was to be demolished, he arranged for bricks from the structure to be placed in a pylon of his magnificent bridge.

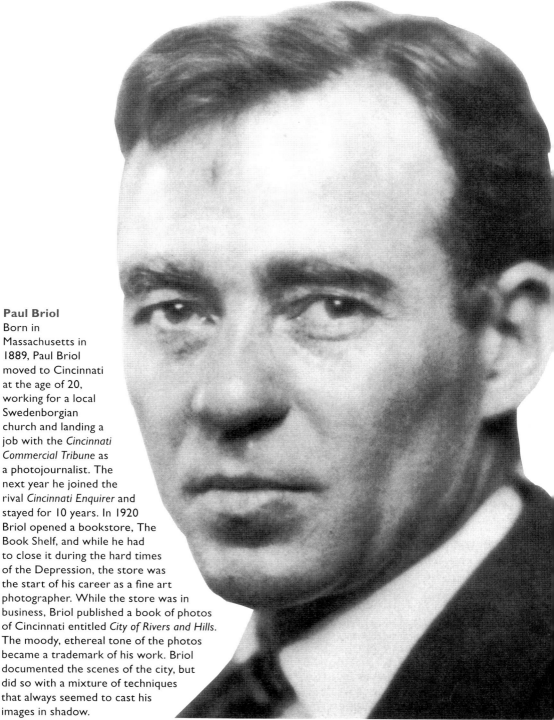

Paul Briol
Born in Massachusetts in 1889, Paul Briol moved to Cincinnati at the age of 20, working for a local Swedenborgian church and landing a job with the *Cincinnati Commercial Tribune* as a photojournalist. The next year he joined the rival *Cincinnati Enquirer* and stayed for 10 years. In 1920 Briol opened a bookstore, The Book Shelf, and while he had to close it during the hard times of the Depression, the store was the start of his career as a fine art photographer. While the store was in business, Briol published a book of photos of Cincinnati entitled *City of Rivers and Hills*. The moody, ethereal tone of the photos became a trademark of his work. Briol documented the scenes of the city, but did so with a mixture of techniques that always seemed to cast his images in shadow.

Libby Holman

If Theda Bara was just the seemingly wild child of the entertainment world, Libby Holman was the real thing. Leaving her hometown of Cincinnati in 1924 where she was the frequent star of campus musical theater productions, Holman headed for New York and Broadway, making a reputation as a sultry chanteuse with her signature song, "Body and Soul." As a torch singer, Libby did well in a number of Broadway revue shows, but it was her life beyond the footlights that made the headlines. After a relationship with DuPont heiress Louisa Carpenter, she married tobacco mogul Smith Reynolds. One night after a party, a shot rang out in their home. Reynolds was dead and Libby was indicted for his murder. Discovered to be pregnant with his child, she was acquitted due to pressure from the Reynolds family. Her second husband committed suicide, her son later died in a mountain-climbing accident, and her lover, actor Montgomery Clift, died suddenly in 1966. Five years later, Libby Holman put on a bathing suit, sat in her garaged Rolls Royce, started the engine, and committed suicide.

George Sperti (RIGHT)

After graduating from the University of Cincinnati in 1923, George Sperti was named to Dean Herman Schneider's think tank, the Basic Science Research Laboratory. It was in this environment, and in 1935, at the Institutum Divi Thomae funded by the Archdiocese of Cincinnati, that Sperti had some of his greatest achievements in developing products that Americans use nearly every day. His inventions include the sun lamp, Aspercreme to relieve arthritis, Preparation H, and methods to produce concentrated orange juice. His ultraviolet lamp was used by industry to safely irradiate milk so Vitamin D could be added. The St. Thomas Institute for Advance Studies, as he renamed it, closed in 1988 when Sperti became too ill to continue his research.

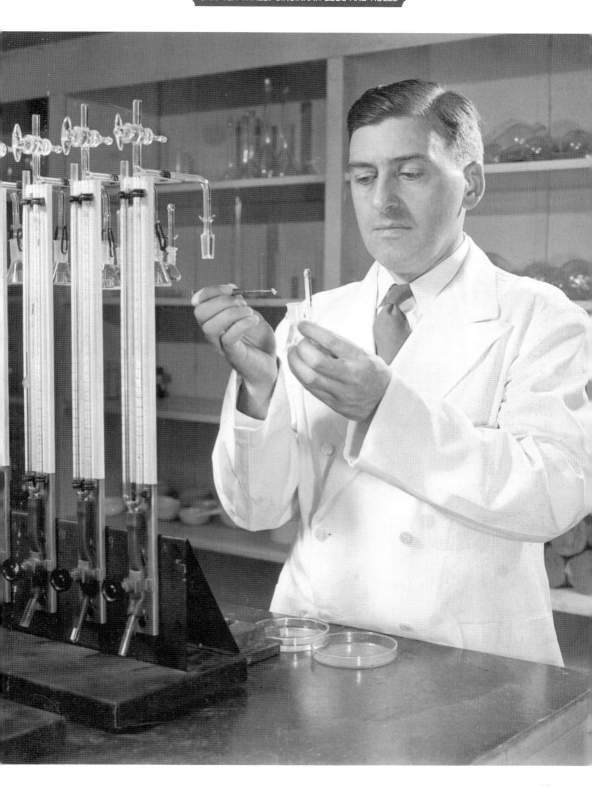

George Elliston

Her parents had already decided their child's name would be "George," so the fact that a daughter was born to them in 1883 didn't faze them a bit. She would still be called George. In a city where odd characters and newspaper reporters often seem to be the same, George Elliston could top them all. Fighting for recognition as a legitimate crime reporter because she was a woman, when police went to the front door of a house to investigate a crime, she shimmied through a back window to get the first look at the scene. She exposed a fake séance, and the medium threw cayenne pepper in her eyes. She interviewed criminals on death row and hung out at the morgue. In her private life, she cadged meals from friends because she was "broke," but still gave elaborate parties at her rural cabin, where she recited poems that she had written. Elliston lived in a coldwater flat, again because she had little money. But she did. George Elliston saved every nickel she could, and when she died in 1946, she bequeathed a fortune to the University of Cincinnati to establish the George Elliston Poetry Foundation to support her true love. Sixty-five years later, the Foundation still funds poetry readings and a comprehensive modern poetry collection.

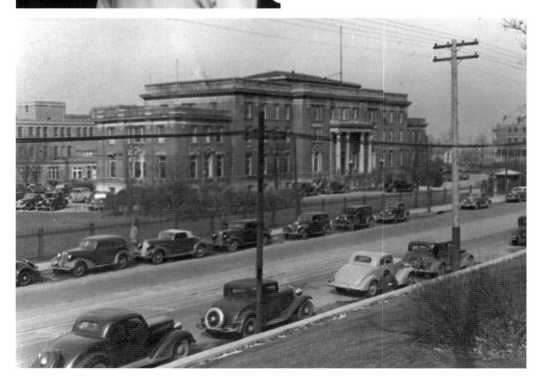

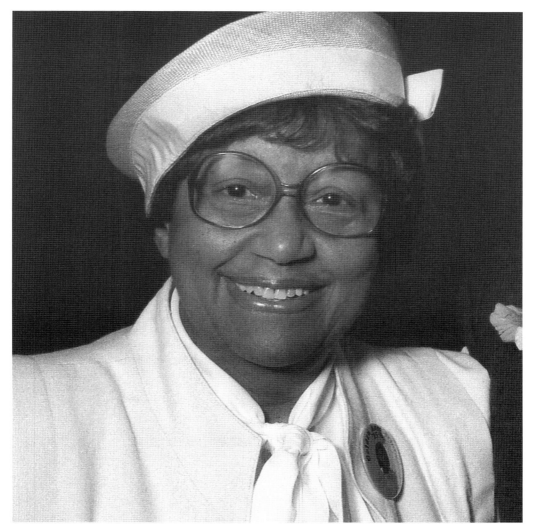

Lucy Oxley

In 1935, Lucy Oxley became the first African American graduate of the University of Cincinnati College of Medicine. Though it was difficult for Oxley to gain admittance to medical school, and she was not always treated equitably by her professors and fellow students, she did find two students who befriended her and were willing to study with her: Ben Felson and Sander Goodman. After graduation, Oxley was denied an internship at Cincinnati's General Hospital because of her race, so she traveled instead to Washington, DC, to further her training at Freedman's Hospital at Howard University. When she completed her internship, she returned to Cincinnati and private practice. Adored by her patients, Oxley was named the Family Physician of the Year in 1984 by the Ohio Academy of Family Physicians. She is pictured here shortly before her death in 1991.

Cincinnati General Hospital (LEFT)

Serving the entire population of Cincinnati, the General Hospital moved in 1915 from its original canal location in the city's basin to Corryville, and what would become known as Pill Hill as other hospitals followed suit.

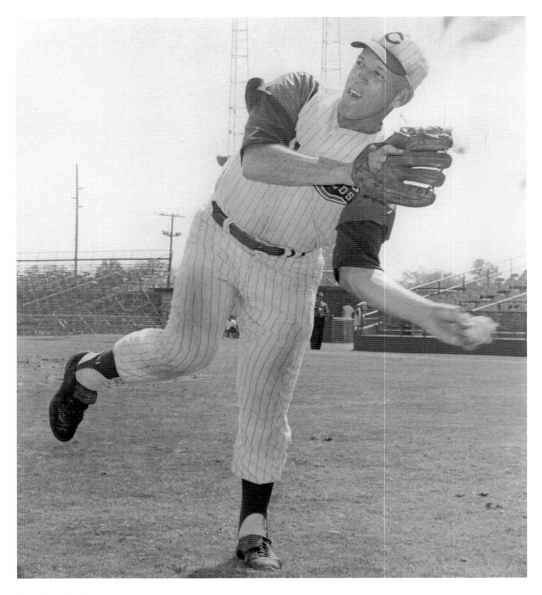

Joe Nuxhall

Celebrated as "The Ol' Lefthander," Joe Nuxhall came on to the Reds baseball scene as a 15-year-old schoolboy pitcher in 1944. He was shelled in his first appearance, but made a better impression when he reached the Majors for good in 1952. Although he would move from the Reds to the Athletics and the Angels during his pitching career, his place was always in Cincinnati. From 1967 to 2004, he was the much-adored voice of the Reds, and when he died three years later, it left a void in the hearts of Cincinnati baseball lovers. That he was a decent, friendly man who would help anyone who asked, devoting his energy to youth sports and his beloved hometown of Hamilton, Ohio, well, that was just a little mustard on the pitch.. Today, Reds fans still have a piece of Joe with them each time they visit the ballpark and see his statue in front of the entrance. As he said at the conclusion of every broadcast, "This is the ol' lefthander rounding third and heading for home."

CHAPTER FOUR

A Future for the Basin and Hills

By 1948, the city was implementing a new master plan, following an earlier one in 1925. Change seemed to come almost too quickly for many citizens and politicians, but the master plan accommodated new highways, riverfront warehouses, an airport, playgrounds, neighborhood demolition and rebuilding, and industrial parks. Much of the plan would be realized in the 1950s and 1960s. And as early as 1925, it was suggested that a new ballpark be built on the riverfront, with the Reds moving from their West End home of Redland Field. The 1948 plan echoed that aspect, and by the late 1950s, discussions were being held about a new locale for professional baseball's oldest team.

The era after World War II was not one of easy opportunity for everyone, however. Race relations were still tenuous at best, and it would take the concerted efforts of many citizens to overturn discriminatory practices in recreation and education. The promise of new beginnings was being realized in many other ways too. Jewish émigrés and displaced Germans found a new home in Cincinnati. Scientific discovery was on the march again with Albert Sabin's research. College basketball teams from Xavier and UC reached new levels of success, and the city had a professional basketball team in the Royals to go along with its professional baseball team. Even professional hockey found a home in the Cincinnati Gardens. Most culturally significant of all, perhaps, was the growing presence of television, which Cincinnati pursued with as much interest and local programming as any city in the nation.

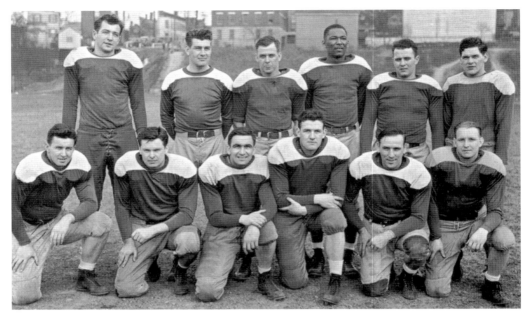

Willard Stargel

One of the most respected teachers and coaches in Cincinnati Public Schools history, Willard Stargel overcame humiliating racism to get there. A veteran of World War II and a stalwart athlete at the University of Cincinnati, his college football squad earned a berth in the 1947 Sun Bowl held in El Paso, Texas. There was a catch to the invitation: Stargel, who was held out of a game against Kentucky in the regular season because he was black, was subjected to the same discrimination for the bowl game. UC president Raymond Walters urged the board to reject the bid, but they decided against him. Stargel was left behind for what would become a tainted victory over Virginia Tech. Willard Stargel rose above it all, and for his entire teaching career, made sure none of his students ever faced such racism under his watch.

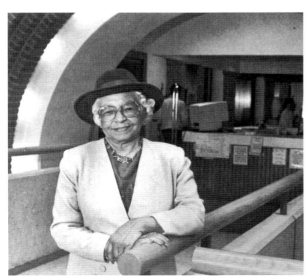

Elsie Austin

Elsie Austin was the first African American woman to graduate from the University of Cincinnati College of Law. The year was 1930, and the racism in the Hamilton County court system closed its law library to her so that she was forced to take the streetcar up the hill to do her research at her alma mater. She persevered, establishing a law practice and serving the Roosevelt Administration during World War II in the Office of Price Administration and following the war, the National Labor Relations Board under Pres. Harry Truman. Her political acumen saw her named as a foreign service diplomat in 1960, serving in North Africa.

Loretta Manggrum

Growing up in southeastern Ohio of Indian and African American heritage, Loretta Manggrum faced racism on a daily basis. She was born in 1896 and by the age of four (shown in the photo at her father's shoulder) she was already showing musical ability, a talent encouraged by her mother, who taught music. By grade school, she was playing the piano in her church, and by her teenage years, she was earning a living by playing at parties and in hotels. When she and her husband and three children moved to Cincinnati in the 1920s, she played organ for silent films in local theaters to support her family and her husband's education. She also started composing her own music. William Manggrum, Loretta's husband, opened a drugstore after the Depression where the entire family was needed to work. But Loretta wanted music back in her life and to go back to school, from which she had dropped out to get married. She earned her high school diploma in 1945 at the age of 49 and her bachelor's degree at age 58. In 1953, when she was 59 years old, Loretta Manggrum became the first African American to graduate from the Cincinnati Conservatory of Music. In 1985, her works were given to the Library of Congress, and a year later, the University of Cincinnati conferred upon her an honorary doctorate of music.

Gustav Eckstein (RIGHT)
To refer to Gus Eckstein as "eccentric" would be to drastically understate the man. So would "nonconventional." However, "brilliant" would come quite close to the mark. Eckstein was a physiologist attached to the University of Cincinnati College of Medicine. On campus, he maintained a cluttered laboratory with odds and ends of the natural world, the better to observe the everyday creatures he loved like canaries, mice, and cockroaches. The apartment he kept at the nearby Vernon Manor Hotel was no less cluttered, and both locales were filled with his notes and manuscripts. More than most scientists in the 1930s and 1940s, Eckstein was able to popularize animal behavior because in partnership with his scientific work, he was a teacher and philosopher as well. His books like *The Body Has a Head* were best sellers on how the nervous system works, what lurks behind sleep patterns, and how animals measure time. Totally devoted to studying the world around him, Eckstein favored the view he had of it at night: "The human mind at such a moment may reflect that all the glories of night are a consequence of a trifle of shadow that lies back of the earth."

Bleecker Marquette
For over a century, Cincinnati activists have worked to improve housing conditions in the city. One of the earliest advocates was Bleecker Marquette, the executive director of the Better Housing League. Marquette was nationally recognized for his skill in developing planned housing for the disadvantaged. In 1933, he worked with Alfred Bettman, chair of the Cincinnati Planning Commission, to create the Cincinnati Metropolitan Housing Authority. Its establishment possible because of federal funds from the Depression-era National Recovery Act, the CMHA led the way to redevelop the West End. The result was Laurel Homes. Lincoln Court and Winton Terrace soon followed. This planned integrated public housing was innovative for its time, and Marquette's influence in the process was felt for decades.

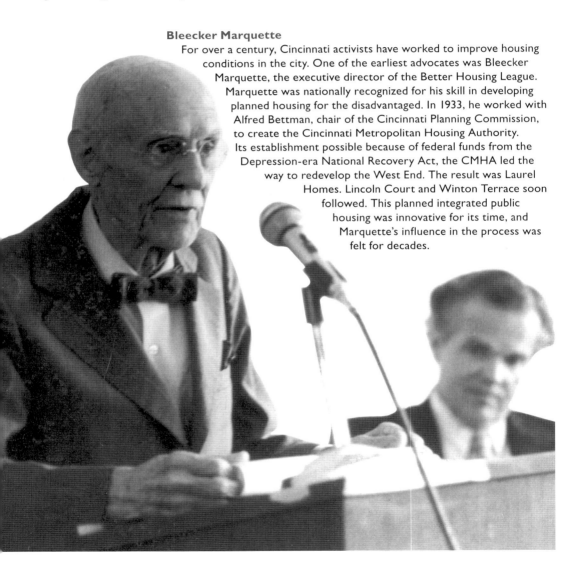

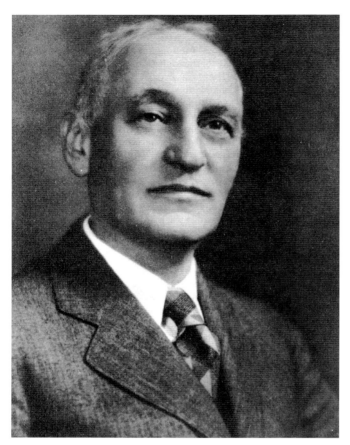

Alfred Bettman
Considered one of the primary advocates of modern zoning in urban planning, Bettman had a national reputation for legislative work in city development. Working on Ohio legal cases involving proper land use, with which he had enormous success, he was called to Washington, DC, in 1917 as the United States became directly involved in World War I. He served in the War Emergency Division performing legal work on espionage cases, convincing Pres. Woodrow Wilson to issue clemency orders for dozens of prisoners. Once back in Cincinnati, Bettman continued his urban planning career.

Ladislas Segoe
One of Bettman's principal cohorts in organized city planning was Ladislas Segoe, a Hungarian immigrant who became one of the country's most respected planning consultants. Segoe and Bettman developed a Master Plan for Cincinnati, elements of which are still continued in contemporary local urban design, particularly for highways, business placement and access, and neighborhood boundaries. Segoe was a man of vision, immersing himself at every step of planning urban renewal and revitalization.

Otto Huebener

World War I flying ace, physician to Kaiser Wilhelm in exile, ladies' man, and circus performer, Otto Huebener was one of Cincinnati's most eccentric and amusing characters for the decades before and after World War II. Huebener was a German gentleman, devoted equally to refined manners and good times. It is said that hearing of his service to the Kaiser that Adolf Hitler requested a meeting with him. On the train journey to meet with Hitler, Huebener met a beautiful lady and decided to forego the meeting. After all, she was a redhead. And, living in the United States when World War II broke out he allegedly sent a congratulatory telegram to Hermann Goering for a bombing raid, not because he believed in the Nazi cause at all, but because it was the gentlemanly thing to do given that Goering had been one of his companions in the German air force in World War I. Ultimately, the action landed him in an internment camp in Wisconsin for a year. Following the war, Huebener would save just enough money from his medical practice in Walnut Hills to routinely head off to Europe on a whim and party until his money ran out. And, whenever the Barnum and Bailey Circus came to Cincinnati, everything else was put on hold so he could attend the performances. At one point, he even took part himself, riding Roman style on two horses around the ring, a skill he perfected at the riding stables he frequented on West Fork Road.

Anneliese von Oettingen

A successful ballerina in Germany, von Oettingen immigrated to America in 1947 and opened a ballet school in Cincinnati in 1948. The first successful school of ballet in the city, von Oettingen's dance studio provided the training for scores of performers. She became the choreographer for the Cincinnati drama guild and was instrumental in introducing liturgical dance to the city. Perhaps most noteworthy about her career, however, is that von Oettingen was one of the first dance teachers to introduce ballet movements to athletes, working with Olympians, football players, and the Cincinnati Royals basketball team. She was even featured in a *Sports Illustrated* article about the ballet camp she established in the Adirondack Mountains that treated pro football players like they were in boot camp. In 1962, she helped found the Cincinnati Civic Ballet, and over the remainder of her life she was showered with awards for her innovative teaching of dance movements.

The von Volborth family

In 1953, the von Volborth family arrived from Germany—Carl Alexander, Rose, and their sons Michael, Christopher, and Peter. Descended from several lines of European royalty, the family also had a long connection with the prominent philosophers, physicians, and authors in their native land. Carl was a noted artist and heraldry expert and found work teaching art and painting commissioned portraits in Cincinnati. First living in Walnut Hills, the sons quickly adapted to American life with the aid of the Germans who had preceded them. Christopher remembered that it was Anneliese von Oettingen who introduced him to fried chicken at the Greyhound Tavern after an afternoon at Butler State Park in Kentucky. The top photo shows the family standing on a hillside in Mt. Adams, and in the bottom image, Rose is at a party with local judge William Dammerall, a bon vivant who lived in Clifton's Probasco mansion and often held elaborate parties for his friends, sometimes dressing as Dracula to chase the von Volborth boys. The fact that the house was haunted added to the fun.

Postwar German Expatriates
In the aftermath of World War II, Cincinnati became the refuge for a number of expatriates like the von Volborths from Germany. Little known, and subsequently ignored in Cincinnati's frequent extolling of its "German-ness," an enclave of this group was the disenfranchised aristocracy and other well-born Europeans. Artistic, cultured, and highly educated, they were left with few economic resources in their new homeland. An Austrian duke became an usher at the Taft Theatre. A Hungarian count found work as a waiter. Despite these circumstances, these expats contributed to the art, music, and dance scenes, and formed their own subgroup within Cincinnati's German community, gathering together for elaborate parties and dinners.

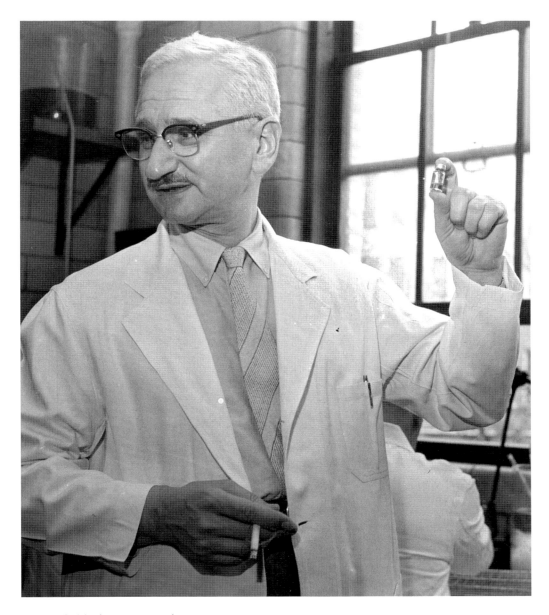

Albert Sabin (ABOVE AND LEFT)
It is difficult for Americans today to comprehend the ravages of polio sixty years ago and the fear it engendered. For decades the disease was a baffling nightmare. Medical researchers sought a vaccine to fight it, and people contributed millions of dollars in a "March of Dimes" to fund the research. Finally, there were breakthroughs in the 1950s. First, Jonas Salk developed a killed vaccine that had some positive effects. But it was Albert Sabin at Cincinnati Children's Hospital and the University of Cincinnati who came up with a weakened live virus oral vaccine that prevented the intestinal infection of polio. After testing around the world on over 100 million people between 1955 and 1960, Sabin's vaccine was ready for general use. It was introduced to 180,000 Cincinnati children in 1960. Fifty years later, polio has nearly been eradicated throughout the world.

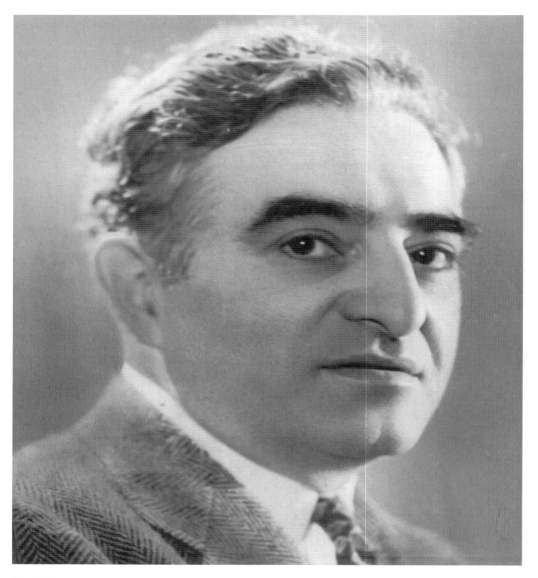

Max Elkus
"One block, two blocks, three or maybe four. Walk a little further down to Max's Clothing Store. Finest clothing, sportswear, and slacks, you really save your money when you buy from Max." That little musical radio jingle in the 1940s called shoppers to Max Elkus's store at Central Avenue and Seventh Street, a business that also had strong connections to Cincinnati's sports heritage. Growing up in Cincinnati, Max was a prominent amateur pitcher for the Cincinnati Spears, and even had a tryout with the Reds. One day, DeHart Hubbard, who by then was working with the Cincinnati Recreation Commission, came into the store with a young boxer. He introduced him to Max as an up-and-coming amateur who needed a job. The result was the development of a family relationship between Elkus and Ezzard Charles. Max and his sons Bob and Gene served as Ezzard's friends and managers, and even after Charles left for other management, he would always seek out Max before a bout, trusting the love and guidance always given him by the Elkus family.

Ezzard Charles

Cincinnati's greatest boxer was Ezzard Charles (inset), who held the heavyweight crown from 1949 to 1951, cementing his recognition with a 1950 victory over his hero, Joe Louis (shown below). Charles was a hard hitter, but never a true knockout artist. His approach in the ring was tempered by a tragedy in 1948. Fighting a young boxer named Sam Baroudi in a Chicago bout, Charles knocked him out in the 10th round. Baroudi never regained consciousness and died the next morning. According to friend and manager Bob Elkus, Charles never got over Baroudi's death and from then on, only boxed hard enough to win. Following his loss of the title to Jersey Joe Walcott in the summer of 1951, Charles tried to recapture his championship with two bouts against Rocky Marciano, acknowledged to be two of the greatest fights in boxing history. Charles's last days were spent immobile in a wheelchair, his body destroyed by Lou Gehrig's disease. The champ died in 1975.

Wallace "Bud" Smith

Bud Smith lived to fight, and died trying to prevent one. An outstanding amateur lightweight, Smith fought for the United States in the 1948 Olympics held in London, winning the bronze medal. Turning pro, he had a short reign as the lightweight champion in 1955 and 1956, but his success in the 1950s was tempered by a management team in thrall to organized crime figures. Smith eventually finished his fight career and came home to live a quiet life in Cincinnati. For years that was the case, but in 1973, Smith came to a tragic end. One evening he was on the street talking to a female friend. Her estranged boyfriend accosted her, threatening her with a gun. Smith stepped forward to protect her and defuse the confrontation. A shot rang out, and Smith was dead from a bullet to his head. His was a life of struggle and violence that ended sadly and too soon.

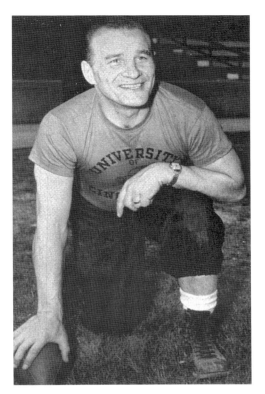

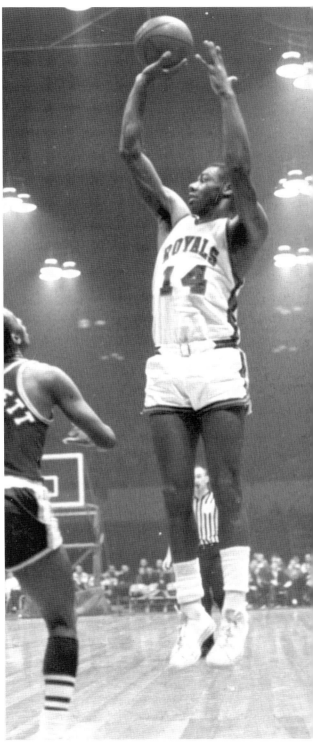

Sid Gilman

One of the greatest strategists in football history, Sid Gilman was the coach of the University of Cincinnati Bearcats during its golden age on the gridiron. From 1949 to 1954, Gilman led the 'Cats to a 50-13-1 record. He originated the use of game film to study positioning on the field and came up with the idea of a split end on offense, along with option plays. After leaving UC, Gilman coached in the National Football League and was inducted into the Pro Football Hall of Fame in Canton, Ohio.

Oscar Robertson

Robertson was the preeminent college basketball player of his day, earning three consecutive National Player of the Year awards while at UC from 1958 to 1960. Had freshman players been eligible for varsity competition at the time, he undoubtedly would have acquired a fourth accolade. He went on to a long career with the Cincinnati Royals and the Milwaukee Bucks en route to a place in the National Basketball Hall of Fame.

Jack Twyman and Maurice Stokes

Their story was one of friendship that knew no boundaries. Jack Twyman and Maurice Stokes were star players for the Cincinnati Royals in 1958. In the last game that season, the Royals were playing the Minneapolis Lakers when Stokes went up for a rebound. He fell to the court, hitting his head. Stokes didn't give it much consideration, but three days later on the flight home to Cincinnati after a playoff game with the Detroit Pistons, he had a seizure and collapsed. Diagnosed with post-traumatic encephalopathy, he was paralyzed and couldn't speak. His career was over, and Stokes would spend the rest of his life in a hospital. And in an age when players had little or no insurance protection, his situation became a financial nightmare. His teammate, Jack Twyman, stepped forward and became his legal guardian. Through benefit games and donations, Twyman gathered support for his friend. Year after year, he saw to it that Stokes was given therapy until he reached the point where he could walk a bit with the aid of braces and regain some speech. This image is of Twyman and Stokes with basketball great Wilt Chamberlain and the Philadelphia Warriors before a game at the Cincinnati Gardens. On April 6, 1970, 12 years after his accident, Maurice Stokes died.

Waite Hoyt

Hoyt had a Hall of Fame career in the 1920s and 1930s with the New York Yankees, but Cincinnatians know him more for his eloquent voice in broadcasting Reds games. In 1941 he landed a job doing game play-by-play on the radio, and soon thereafter he became a fan favorite. With Burger Beer as his sponsor until the close of his broadcast career in 1965, Hoyt regaled his listeners during rain delays with stories about his Yankee days in the time of Babe Ruth and Lou Gehrig. He even produced a record album entitled, appropriately enough, *The Best of Waite Hoyt in the Rain*. Hoyt is shown here with Reds great Frank McCormick.

The Cincinnati Reds Hall of Fame

In 1958, the Cincinnati Reds established a team hall of fame to honor the generations of players, executives, and managers who made the city the home of professional baseball. That inaugural group of inductees included five members of the 1939–1940 Reds squad that won two National League pennants and a World Series. From left to right, Bucky Walters, Ernie Lombardi, Johnny Vander Meer, Frank McCormick, and Paul Derringer.

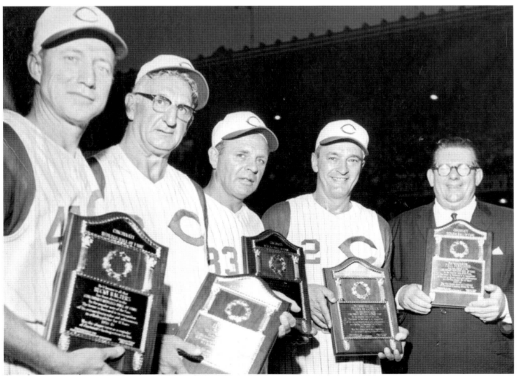

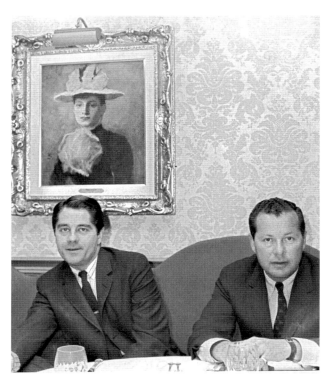

The Comisar Brothers

Perhaps no Cincinnati restaurant has had a reputation for fine dining more than that of the now-defunct Maisonette. First opened in 1949, it featured French cuisine in a setting of fine art and elegant conversation. Jackets and ties were required and casual dress was forbidden. The Maisonette was established by Nathan Comisar, and after his death, his two sons Lee and Michael J. (shown here) continued the family business, relocating to its famous Sixth Street location in 1966. The Comisars brought in the most innovative and skilled French chefs, earning themselves the much-coveted Mobil 5-Star rating for 40 consecutive years. The restaurant still evokes wonderful memories of rich foods, fine wines, and perfect dining experiences.

Foss Hopkins

Murder Is My Business. That was the title of flamboyant defense attorney Foss Hopkins's memoir, published in 1970. Beginning in 1924, the colorful lawyer defended over 500 accused murders, only two of whom were sent to the electric chair. One of his most notable defenses was of Edyth Klumpp, brought to trial for murdering the wife of her lover, William Bergen. This photo was taken during the trial by news photographer Jack Klumpe. With the unspoken cooperation of the judge, who conveniently looked away on occasion, Klumpe managed to snap several "accidental" photos of Hopkins's histrionics when photography was forbidden in the courtroom.

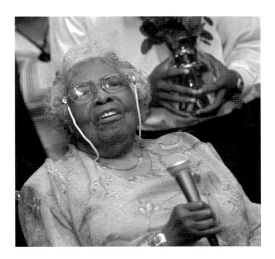

Georgia Beasley
In 1925 as the rest of the graduating class of the University of Cincinnati mustered to receive their diplomas, Georgia Beasley walked along. University commencement officials wanted her to walk in separately, but she refused—she wouldn't walk in front or in back, but rather only in the middle with her fellow grads. As the only African American graduate that year, she stood alone, with white students in front of and behind her. After a long career as a teacher, Georgia Beasley developed a set of truths she lived by, one of which was, "First you have to be right. Then demand by your actions to be treated right." She is shown here at a 2004 celebration in her honor at UC's African American Cultural and Research Center.

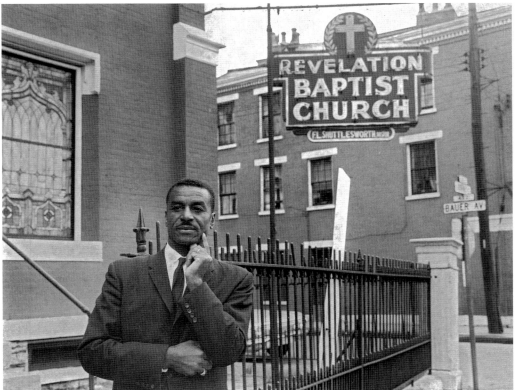

The Reverend Fred Shuttlesworth
Birmingham, Alabama, often seemed to be the epicenter of civil rights action in the 1950s and 1960s, due in no small part to the Reverend Fred Shuttlesworth. Along with the likes of Martin Luther King Jr. and Ralph Abernathy, Shuttlesworth helped found the Southern Christian Leadership Conference in 1957 to fight for social justice and racial equality. For many years, he also ministered at the Revelation Baptist Church in Over-the-Rhine, carrying the struggle to Cincinnati as well.

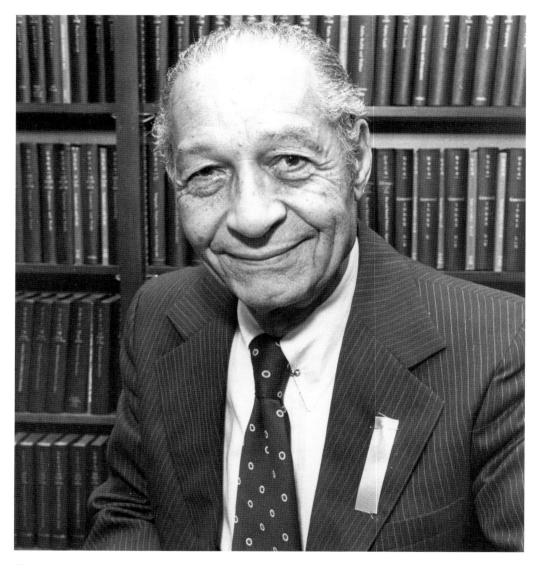

Theodore "Ted" Berry

Ted Berry was born in 1905 in Maysville, Kentucky to a deaf-mute laundress for a white family. Moving with her family to Cincinnati when Berry was very young, Cora Parker placed her son in Jennie Porter's Stowe School in the West End. It was the beginning of a life of accomplishment for Berry. He flourished under Porter's insistence on excellence for her African American charges, and when he became the first black valedictorian at Woodward High School, he moved ahead with confidence and determination. Berry earned his bachelor's degree at the University of Cincinnati, paying for his schooling as an ironworker. He then went to law school at UC, graduating in 1931. His subsequent legal career led him into the civil rights movement in defending the Tuskegee Airmen in 1945, serving as legal counsel for the NAACP, litigating for fair housing in Cincinnati, and working in the Lyndon Johnson administration in the Office of Economic Opportunity and the Community Action Program. He also became the first African American mayor of Cincinnati. Ted Berry was a giant figure in Cincinnati history, strong and forceful with a voice for equality that was only silenced by his death in 2000.

Al Lewis

Children's television host Al Lewis was a mainstay on the airwaves from 1950 to 1985, with *The Uncle Al Show*. Clad in a straw boater and bow tie, Lewis was joined on the show by his wife Wanda as Captain Windy and other characters such as Lucky the Clown. It is estimated that nearly half a million children visited the show over the decades, including in this image, twins Joan and Julie Fenton, on the bottom left with their little sister Amy. Things did not always go smoothly during the show's production; the Fentons remember Lucky the Clown being "especially mean" and short-tempered on the day of their visit.

Paul Dixon

He was affectionately known as "Paul Baby," the "Mayor of Kneesville." With his binoculars scouting the audience for pretty legs, and his famous marriage of two rubber chickens on the air, Paul Dixon's morning television program on WLWT in Cincinnati was noted for his gentle offbeat humor. Television stations in Dayton, Columbus, and Indianapolis also carried his show and made him the toast of housewives from 1955 to 1974.

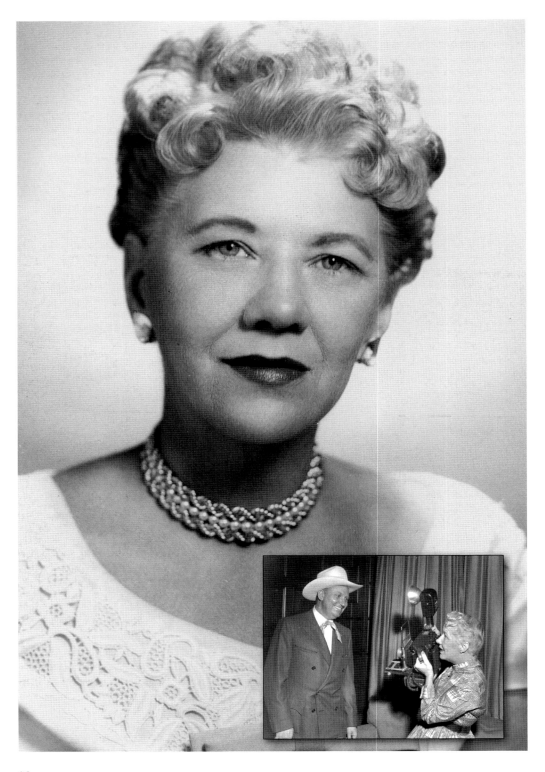

Ruth Lyons (LEFT)

Beginning her broadcast career in 1925 at the age of 20 with a spot on a local radio show, Ruth Lyons would become the most familiar figure in Cincinnati television in the 1950s and 1960s when she hosted her music-and-talk show. Her signatures were a handheld microphone that was hidden in a bouquet of flowers, and her segue from conversation with a guest to pitching a commercial product. Lyons attracted the most famous entertainers in the country, like Bob Hope and, pictured here with her, Gene Autry. If they were headliners anywhere in Cincinnati, or if she heard they were passing through town, she got them on her show. Her most famous program was *The 50/50 Club,* so named because her show expanded from fifty women invited to the audience for the radio program to 100 when the show moved to television in 1949. She began the Ruth Lyons Christmas Fund in 1939 to provide toys for every hospitalized child in Cincinnati, as well as hospital equipment. Over the years, millions of dollars have been raised through the fund. Ruth Lyons retired from broadcasting in 1967 and died in 1988.

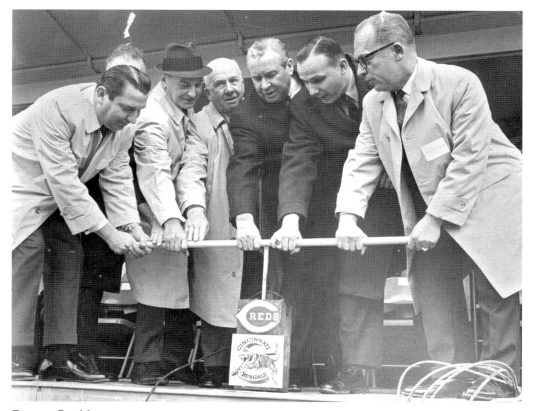

Eugene Ruehlmann

Cincinnati mayor Eugene Ruehlmann led a concerted effort with civic and business leaders, and leaders in football and baseball, to bring a new stadium to Cincinnati. During Ruehlmann's tenure as mayor from 1967 to 1971, Cincinnati faced urban renewal, race riots, and a regenerating downtown. He handled everything with common sense and diplomacy. Here he is shown (second from right), inaugurating the construction of Riverfront Stadium with (from left) Francis Dale, president of the Reds, Paul Brown, head coach of the Bengals, Warren Giles, president of the National League, Ohio governor James Rhodes, and Cincinnati city manager Richard Krabach.

Paul Brown

One of the greatest coaches in football history, Paul Brown was an Ohio success story, successfully leading high school, college, and professional teams to championships. After losing ownership of the Cleveland Browns, he decided to build a team in the American Football League. To that end, he worked with Cincinnati officials to construct a home for the Bengals. Brought into the AFL in 1968, the Bengals played their first two years at UC's Nippert Stadium before moving into Riverfront Stadium. Here Brown is shown eyeball to neck with assistant coach Tom Bass.

CHAPTER FIVE

Service and Innovation

That new stadium along the river came to pass, and with it a world champion baseball team. The arts flourished in ballet and orchestral music. Cincinnati held to its heritage of service and innovation, the former through business opportunities and the change in its municipal university to state status that brought more funding for research and teaching, the latter through seemingly banal machines like the zamboni. Adapted for artificial turf from its original use for hockey arenas, the zamboni outfitted for the Reds was one of the first in baseball, plodding along at nine miles per hour, sucking up water from a rain-drenched turf and making rainouts unusual. That, of course, meant ticket sales for more single games, with accompanying concession and parking income. It was good business.

The number of concerts and festivals in Cincinnati exploded to fill calendars. Cincinnatians loved their food, loved their neighborhoods, loved their churches, loved their musicians, and loved their ethnicities. All the festivals seemed to merge into a continuing lovefest. It was one more characteristic of local life that would span the next two generations into the 21st century.

The notion of service came with a sense of obligation. It was imperative that effective school desegregation take place. It was essential that constitutional rights for dissident opinion and individual expression be acknowledged and protected. And, there were some remarkable individuals who saw to it.

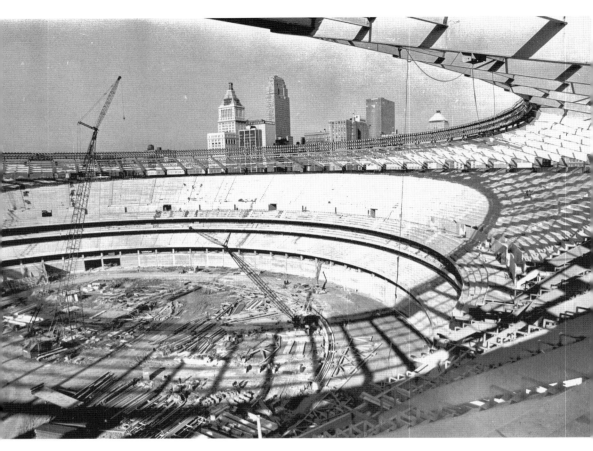

Riverfront Stadium
The stadium that resulted from the steady —and sometimes frenzied—work of Cincinnati politicians, Reds owners, and the owner of the new Cincinnati Bengals in the NFL was Riverfront Stadium. Built in the typical stadium design of the 1970s, Riverfront was a concrete saucer on a concrete island, architecturally isolated from the city streets and braced by interstate highways. It was multipurpose, with the artificial turf eliminating rainouts for many baseball games, rotating stands for football games, and able to host a concert one night, a religious rally days later, and a ballgame the week after that. For baseball fans, they loved it because it became home of the Big Red Machine.

George "Sparky" Anderson and Johnny Bench (RIGHT)
Manager Sparky Anderson and catcher Johnny Bench were key cogs in the Big Red Machine. Their leadership from the dugout and the field guided the Cincinnati Reds to four World Series appearances and two championships. Both are Hall of Famers and beloved in the Queen City. Cincinnatians can even forgive Californian Anderson's pronunciation of the city as "Cincinnata."

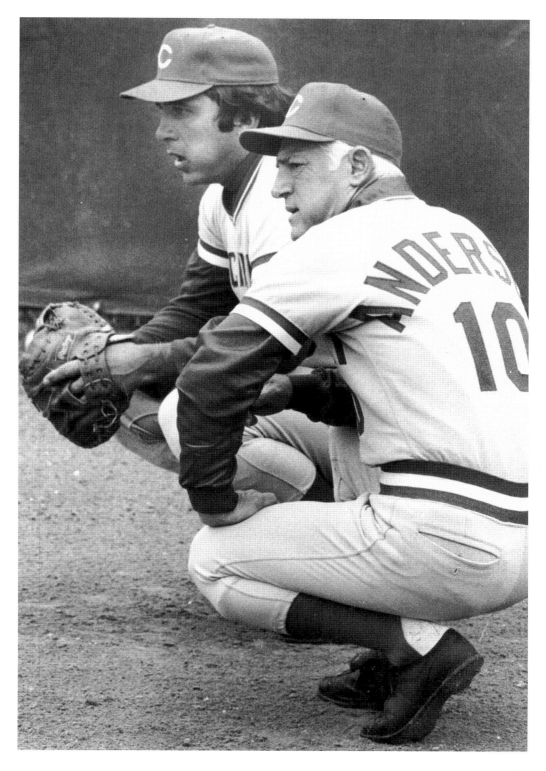

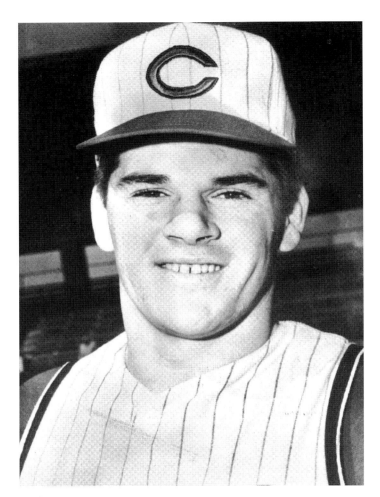

Pete Rose

Sure, he had his faults. He gambled on baseball and lied about it for years. He is still banned from the game. He served time for income tax evasion. But if anyone could be considered the quintessential working class hero in Cincinnati, it would be Pete Rose. From his arrival in the Major Leagues in 1963 to the end of his playing days in 1986, no one hustled like "Charlie Hustle." With many athletes there are iconic images, and for Rose they are his headfirst slide into a base, the clutching of his batting helmet as he rounded first base on a hit, his running to first base on a walk, and his head jerking to follow a pitch into the catcher's mitt. Cincinnatians are also unlikely to forget him crashing into the plate in the 1970 All-Star Game held at Riverfront Stadium, knocking over American League catcher Ray Fosse and scoring the winning run.

Bernie Stowe

Stowe began a lifetime with the Cincinnati Reds when he became a clubhouse boy in 1947. He was named as the clubhouse manager in 1968 and over the decades became almost as well known as any player on the field. Caring for equipment and uniforms, and making everything run smoothly, Stowe was the man behind the scenes that everyone depended upon. In 2003 when the Reds opened Great American Ballpark, they named the clubhouse in his honor.

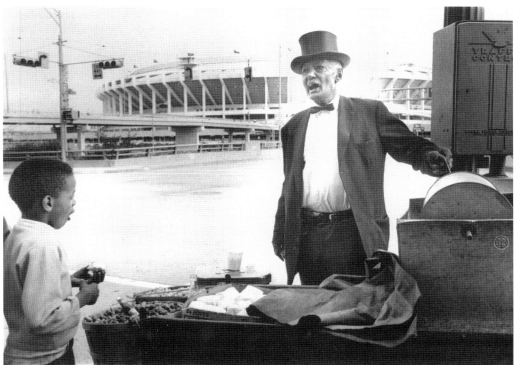

"Peanut Jim" Shelton

When the Cincinnati Reds played at old Crosley Field in the West End, fans often were greeted as they approached the ballpark by Peanut Jim Shelton in a black coat and his trademark top hat. For decades, Shelton stood by his cart, offering fresh roasted peanuts. And when the Reds moved to the new Riverfront Stadium in 1970, Shelton moved with them.

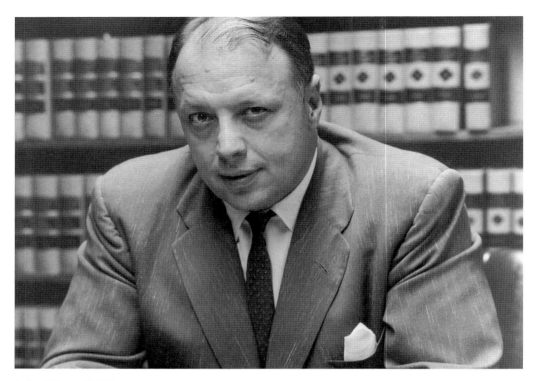

John "Socko" Wiethe

Well deserving of his nickname, Socko Wiethe was a hard-nosed athlete during his day who maintained that persona as a coach and as a politician. A football star at Xavier University, he went on to play for the Detroit Lions. He became the basketball coach at the University of Cincinnati in 1946, building the Bearcats into a national power. He later held the chairmanship of the Hamilton County Democratic Party. Equally at home in gyms or in smoky back rooms, Wiethe was the consummate negotiator until his death in 1999.

Jacob Rader Marcus

Marcus was the personification of the erudite scholar. Born in 1896, he traveled to Cincinnati in 1911 as a 15-year-old to undertake rabbinical studies at Hebrew Union College. However, his true calling was as a historian who devoted most of his life to documenting the American Jewish experience. In 1947 he established the American Jewish Archives on the campus of HUC, recognizing that primary resource material was essential in chronicling the story of his people. He died in 1995 as he neared his century mark, and it is said the floors of his home fairly groaned with the weight of the bookshelves throughout the rooms. Today, the American Jewish Archives he founded is named in his honor.

Patricia Corbett

In creating a foundation with her husband J. Ralph Corbett in 1955, Patricia Corbett demonstrated her deep devotion to the performing arts. It is reasonable to say, too, that without the Corbetts's involvement beginning in the 1960s, the University of Cincinnati's College-Conservatory of Music would not have been able to maintain its world-renowned reputation. In addition to that school, Patricia Corbett also worked generously on behalf of Music Hall, the School for the Creative and Performing Arts, Cincinnati Ballet, Northern Kentucky University, and the Cincinnati May Festival, just a few among many organizations. Philanthropists like the Corbetts were mostly driven by passion, and in the case of Patricia Corbett, it was her passion for exquisite music, dance, and theater.

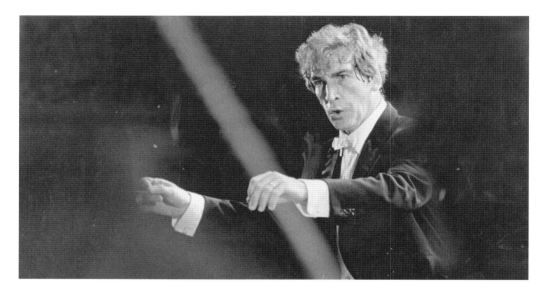

Thomas Schippers

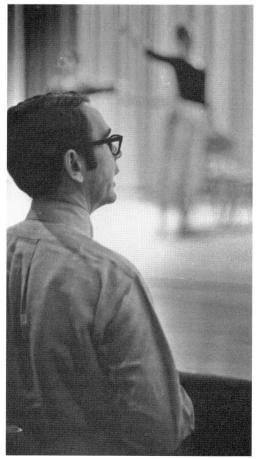

Thomas Schippers was a musical child prodigy, learning the piano at age four, graduating from high school when he was only 13, and then attending Juilliard and the Curtis Institute. By age 21, he was in demand as a conductor for operas in New York City and around the world. Though he had a solid post as conductor of the Metropolitan Opera, Schippers was lured to lead the Cincinnati Symphony Orchestra in 1970. Handsome and talented, he cut an intense dramatic figure with the baton, and his arrangements helped foster the international reputation enjoyed by the CSO. With a brilliant career ahead of him, though, tragedy struck. Diagnosed with lung cancer, the dynamic Schippers died in 1977 at the age of 47.

David McLain

A premier figure in local dance history, David McLain was the artistic director of Cincinnati Ballet from 1966 to his untimely death in 1984 at the age of 51. Under McLain's leadership, the company achieved national recognition in the 1970s, growing from a civic company to professional status and praise as a leading regional ballet organization. At the same time he worked as artistic director for Cincinnati Ballet, McLain also headed the dance division at the College-Conservatory of Music.

Gerry Faust

Mention legendary coaches at any level in Cincinnati sports and one of the names at the top of the list will always be the redoubtable Gerry Faust. Beginning his outstanding football legacy at Moeller High School in 1960 with a freshman team, Faust would build it into a varsity program that won five state championships, four media-decided national championships, and a long string of conference titles. In 1980, Faust resigned from Moeller to take the head coaching job at Notre Dame University. Although he did not find much success there, his reputation in Cincinnati was a steadfast part of sports history.

Bob Lewis

One of the greatest coaches in Cincinnati high school football history was Bob Lewis of the Wyoming Cowboys. Lewis coached the Cowboys from 1956 to 1978, compiling a record of 198-21-7. In 1962, the Cowboys' defense did not allow a single point, and in 1977 he guided the squad to a state title. With 11 undefeated teams and 23 straight winning seasons over his career, Bob Lewis was the only coach to win state titles in Ohio and across the river in Kentucky.

George Rieveschl

How many millions of people have been helped by Benadryl? Its invention was the work of George Rieveschl, born in 1916 and a graduate of the Ohio Mechanics Institute and the University of Cincinnati. As a UC faculty researcher in the early 1940s, Rieveschl worked on developing a drug that could help relieve muscle spasms. The result was an antihistamine that benefitted allergy sufferers. Leaving the university to develop and test the drug at Parke-Davis Pharmaceuticals, Rieveschl saw Benadryl approved for the market in 1946. In 1970, he returned to the University of Cincinnati as vice president of research and later headed development efforts before retiring in 1982. George Rieveschl died in 2007 at the age of 91.

Henry Heimlich

Inventor of the abdominal thrust technique that bears his name, Henry Heimlich has long been a controversial figure in medicine. The Heimlich Maneuver was developed jointly by Heimlich and longtime research associate Edward Patrick (see the HARP photo on the opposite page), but its efficacy frequently has been challenged as a treatment for choking victims, with some favoring back blows and chest thrusts. In recent years, Heimlich has also been noted for his controversial research in treating HIV with malaria.

The HARP Group (RIGHT)

The HARP group, composed of Henry Heimlich, astronaut Neil Armstrong, George Rieveschl, and Edward Patrick (the name formed from an acronym of their last names), was a biomedical engineering think tank and research organization whose purpose was to use the respective talents of the four individuals to create new products. One of their ideas resulted in prototypes for components of heart-lung machines. The group also explored the possibilities of artificial intelligence.

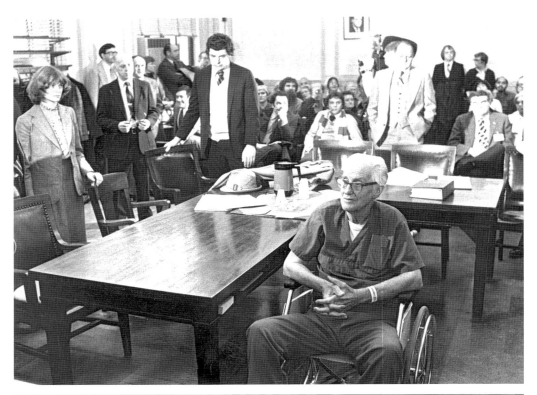

The Reverend Maurice McCracken

A pacifist with a will of iron, Maurice "Mac" McCracken was Cincinnati's conscience. He protested constantly against war, against racism, against gender discrimination, and for equality for women, civil rights for everyone, rights for the poor and disadvantaged, and peace. His actions frequently led to arrests and some stays in a jail cell, but he never gave in. A Presbyterian minister, he integrated his church in the 1960s, setting an example, and he believed, a standard for human decency. Even his advancing age and ill health did not stop him. In these 1970 photos he is seen awaiting trial for protesting against the Vietnam War, while outside his supporters called for his release. When Maurice McCracken died in 1997 at the age of 91, he left a legacy of conviction in one's beliefs and an example to follow them with action.

Daniel J. Ransohoff

If ever there was a "hale fellow well met" ambassador for Cincinnati, it was Danny Ransohoff, who died in 1993 at the age of 71. Mornings would see him walking about the Clifton streets with his dogs' leashes tied around his waist. This, of course, freed his hands to read his newspaper as his pets dragged him about. The rest of the day, and many evenings, saw him giving tours and lectures on the history of the city from the geologic past to the future of downtown. A believer in public broadcasting, he helped found Cincinnati's WGUC radio station and WCET public television. Ransohoff was a social worker by profession, as well as being a nationally recognized photojournalist, working for the United Way and the Community Chest. His photos of Over-the-Rhine in the 1940s and 1950s revealed the necessity of education and social services for a large African American and Appalachian segment of Cincinnati's citizens. And while he happily presented slide shows to newcomers and business executives, Danny Ransohoff was happiest climbing to the heights of Cincinnati's overlooks and pointing out the thousand reasons why he loved the river city so much.

Dick Von Hoene

He was the "Cool Ghoul" on late-night television, hosting horror movies for late-night revelers and insomniacs. Dick Von Hoene was a news anchor and radio show host when he created his character for station WXIX. Wearing outlandish monster makeup and a bad orange wig, he hosted *Scream-In* with his signature cry of "Bleah, Bleah, Bleaaahh." It was campy, and a lot of fun. Von Hoene was part of a great era for oddball late-night television characters in Cincinnati, along with Bob Shreve. Both programs presented scary movies that were alternately classics and bombs. It was the antics of the hosts that carried viewers through the night. Even after his show was cancelled, Von Hoene continued the character of the Cool Ghoul, making appearances at charity events and festivals, and acting in local commercials.

CHAPTER SIX

The Cincinnati Quality of Life

How does one measure quality of life? How does one improve it? For the most part the act of giving transforms quality of life, and not only the giving of dollars. Giving also means time, effort, strength of character and conviction, and teaching by example and with experiential knowledge. In the 1980s, 1990s, and the first two decades of the 21st century, this concern for the quality of life became more widespread in the community than in any age that preceded it.

Past, present, and future, Cincinnati citizens make local life one of emotion, struggle, accomplishment, and wonder.

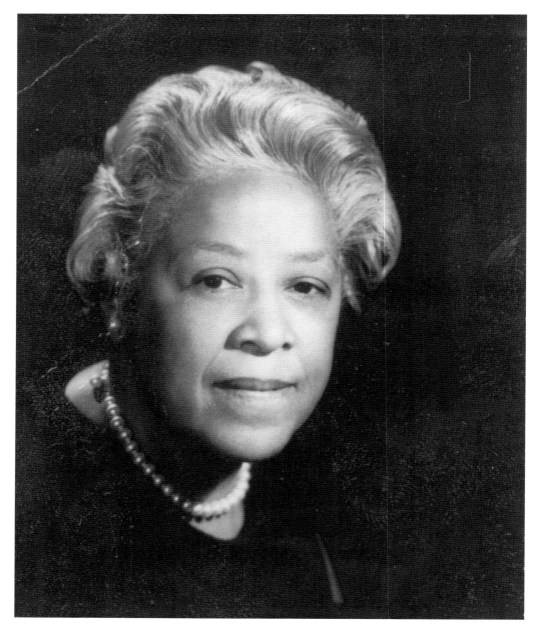

Virginia Coffey

From schoolteacher to community activist, Virginia Coffey established her goal in life to provide hands-on service every day. She began by battling segregation in the public schools when she began teaching in 1924. Later, she served as the executive director of the Cincinnati Human Relations Commission, where she brought together community leaders to construct a practical program for positive change in the city. After organizing the first African American Girl Scout troop in Cincinnati in 1944, she later worked for the Girl Scouts to integrate their day camps. Virginia Coffey died in 2003, after 98 years of a dedicated life.

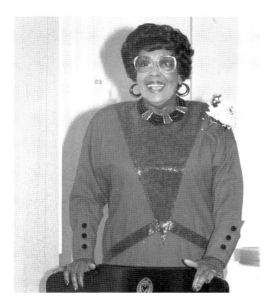

Noel Martin

Noel Martin was one of the most respected graphic designers and typographers of the 20th century. Being mainly self-taught, Martin learned from his contemporaries as well as through experimentation on his own, and earned an international reputation. He mentored many of Cincinnati's young designers. Much of the wonderful publication and exhibit design of the Cincinnati Art Museum and the Contemporary Arts Center throughout the middle decades of the 20th century was from the hand of Noel Martin.

Marjorie Parham

Parham wasn't looking to be in the newspaper business, but when her husband, Gerald Porter, died in 1963, she was left to manage the *Cincinnati Herald,* the city's African American newspaper. From 1963 to 1996, she published the weekly paper, providing news to the community that they often could not get through other media. In 2007 Marjorie Parham was named a Great Living Cincinnatian.

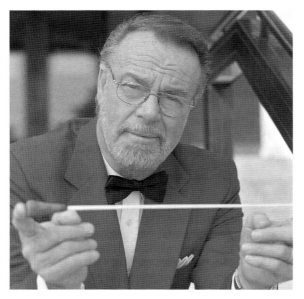

Erich Kunzel, Jr.

Kunzel was the director of the Cincinnati Symphony Orchestra from 1967 to 1977, but his reputation was really made when the symphony created the Cincinnati Pops Orchestra in 1977. Kunzel was named director of the Pops and for the next thirty years received international accolades for the orchestra's performances. Under his leadership, the Pops produced recording after recording, bringing the "classics" of pop music to ever-widening audiences. Kunzel died in 2009, and the next year the School for Creative and Performing Arts named their new home the Erich Kunzel Center for Arts and Education in his honor for his longstanding commitment to music education in Cincinnati.

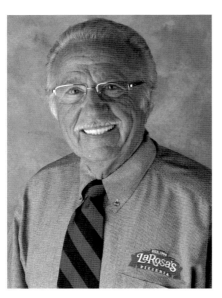

Buddy LaRosa

High school sports would not be the same without Buddy LaRosa. For that matter, neither would amateur boxing or pizza. The premier pizza impresario in Cincinnati, Donald "Buddy" LaRosa opened his first restaurant in 1954. He grew up in the Fairmount neighborhood, raised by his mother and grandmother in an Italian-American community. His father, Tony, had been a local boxer of some repute in the 1930s, sparking a lifelong love of the sport in Buddy. He has been the father figure for local amateur boxing for half a century, sponsoring Olympic hopefuls and AAU fighters. When Buddy's restaurant on Boudinot Avenue burned in 1973, local high school football players arrived to clean it up. In thanks, he began the High School Hall of Fame, a mainstay in local sports for almost four decades.

Marge Schott

Baseball fans remember her as the principal owner of the Cincinnati Reds from 1984 to 1999. With her beloved Saint Bernards, she attended Reds games and brought dozens of children to her seat to get an autograph, one of her great pleasures in life. Marge Schott's larger impact on the community may have been her support of children in other ways: she donated considerable time and money to Children's Hospital in Cincinnati, the Dan Beard Council of Boy Scouts, and the Cincinnati Zoo, just three of many organizations in which she took a deep interest.

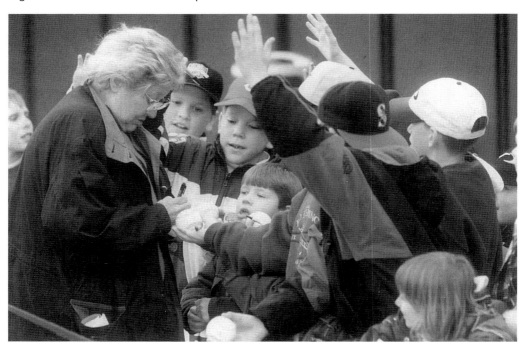

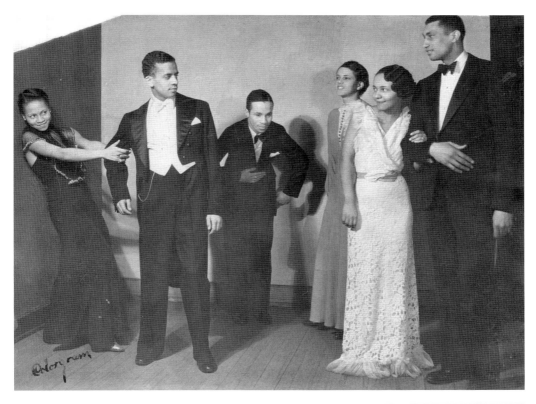

Donald and Marian Spencer

As a couple, Donald and Marian Spencer fought racism and celebrated African American heritage in Cincinnati. They met at the University of Cincinnati, where Donald had helped found Quadres, an organization for the few African American students on campus. Quadres was an attempt to bring an end to discrimination in the many ways it manifested itself at the university in the 1930s, whether it was confining students of color to majors in liberal arts and education, or in not being able to use the YMCA pool along with white students. The organization presented musicals to raise scholarship money (Donald Spencer is pictured second from left in one production) and tried to bring together students of every race. Later, as a teacher and realtor, he fought discrimination in the schools and in the housing market. Marian Spencer was in the forefront of integrating Coney Island in 1955 and was an active member of the Charter Party. In 1983, she was elected as the first African American woman on Cincinnati City Council, and later was a member of the board of trustees at UC. Both Spencers were instrumental in guiding the Cincinnati chapter of the NAACP.

Carl Lindner, Jr.

The value of education sometimes is most apparent to those who have not had the opportunity to earn one. During the Great Depression, Carl Lindner left school at age 14 in order to help out his family's dairy business. His predilection for hard work and a knack for business led him to build a fortune in convenience stores, insurance, and investments. And Lindner always gave back—with both his time and his money. He had endowed schools from the primary level through higher education at the University of Cincinnati. He also contributed heavily to medical research, to hospitals, to charities, and to a multitude of causes in Cincinnati that enriched the lives of hundreds of thousands of citizens.

Louise Nippert

Carrying on a century and a half of generosity to the city and its citizens by the descendants of William Procter and James Gamble such as her late husband Louis Nippert, Louise Dieterle Nippert has been a mainstay in philanthropic affairs. Mrs. Nippert has quietly and continually helped out Cincinnati institutions to better the local quality of life. Art and culture in the city thrive because of her endowments of the Cincinnati Symphony Orchestra, the renovation of Music Hall, and the creation of the College-Conservatory of Music village on the University of Cincinnati campus.

Henry R. Winkler

Henry Winkler personifies the community-involved scholar. Educated at the University of Cincinnati with a bachelor's degree in 1938 and a master's in 1940, Winkler then went on to earn his doctorate at the University of Chicago. An eminent authority on 20th century British history, he spent most of his academic career at Rutgers University before returning to Cincinnati in 1977 as an executive vice president at UC. He assumed the presidency later that year and served until 1984. During that time and all the following years since, Henry Winkler became known for his gentle intellect and his forthright voice for civic fundraisers and community service boards.

Thane Maynard

He is the "90-Second Naturalist," heard on radio stations across the nation. The director of the Cincinnati Zoo & Botanical Garden, Thane Maynard is the face of wildlife conservation in Cincinnati, and his love for the natural resources of the world paired with his ease in explaining the wonders of animal behavior convey the importance of effective stewardship of the planet. Here he is shown introducing the zoo's binturong Lucy, better known as a "bearcat," to former University of Cincinnati president Nancy Zimpher.

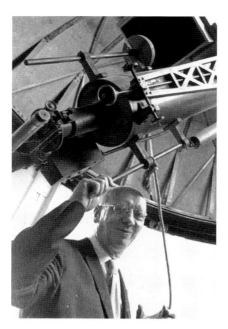

Paul Herget

What exactly is a hyperbolic paraboloid? In the food industry, it is the shape of a Pringles potato crisp, but how does that relate to a prominent astronomer? Paul Herget, director of the Cincinnati Observatory from 1943 to 1978, was one of the first to apply computer technology to the computation of planetary movement. His specialty was the orbital paths of comets, that is, parabolic curves. It is believed that in the 1960s when Procter & Gamble searched for a way to effectively package its new snack, Herget hit upon the design that would minimize breakage.

John Ventre, Dean Regas, and Craig Niemi

The Observatory's mission of education is carried on today by a dedicated staff of astronomers and historians through its incarnation as the Cincinnati Observatory Center. Pictured from left to right are John Ventre, Dean Regas, and Craig Riemi, who lead in coordinating tours, research, and outreach activities at the National Historic Landmark, fulfilling the intent started over 150 years ago by Ormsby MacKnight Mitchel.

Gene Kritsky

He's the cicada man. But, he's also the beekeeper man. Gene Kritsky, a professor of biology at Mt. St. Joseph College, is an entomologist constantly researching his passion, though Cincinnatians tend to see him only when cicada cycles fill the air with ear-splitting buzzing and the large devil-eyed bugs flutter about. Kritsky first became involved in cicada research as an undergraduate at Indiana University, and over the subsequent decades, he has turned every cicada invasion into an entertaining adventure with demonstrations and appearances that explain these winged lives. Just as importantly, he is an expert on honeybees and serves as the beekeeper for Spring Grove Cemetery and Arboretum. The author of several books and articles on both cicadas and bee culture, Kritsky readies the city for each major cicada invasion, the next one coming in 2021. As far as these matters go, Gene Kritsky likes his cicadas battered and fried, with some good hot sauce on the side.

Catherine Roma
For Catherine Roma, singing is more than song. Singing is also a philosophy, a political statement, a social manifesto, and a joyful noise. In 1984, Roma was immersed in her studies at UC's College-Conservatory of Music, working on her doctorate in choral conducting. She decided to form a Cincinnati women's choral group, so she sent out a call for auditions. Shortly thereafter, MUSE was born with a score of women as part of a movement to celebrate and acknowledge the richness of difference and diversity through the beauty of their voices. A quarter-century later, MUSE has performed abroad, produced recordings, and invigorated local music. Under Roma and her choir, the power and pleasures of song remain a strong part of the Queen City's 200-year love affair with musical performance.

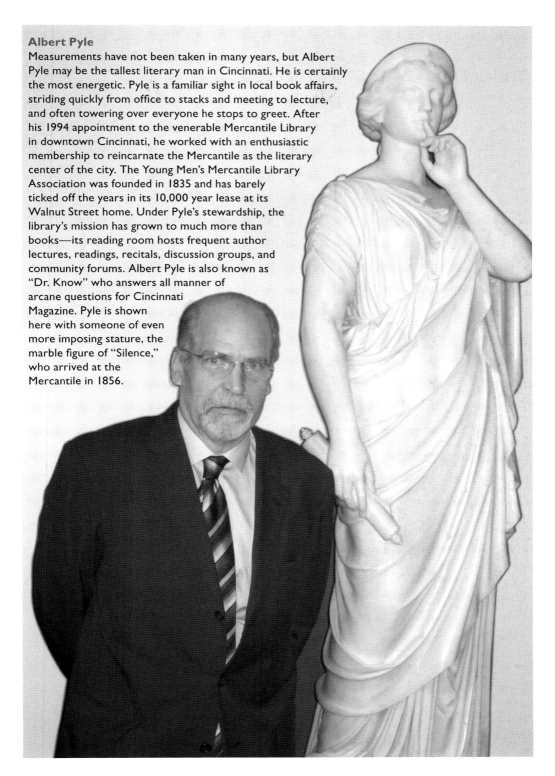

Albert Pyle

Measurements have not been taken in many years, but Albert Pyle may be the tallest literary man in Cincinnati. He is certainly the most energetic. Pyle is a familiar sight in local book affairs, striding quickly from office to stacks and meeting to lecture, and often towering over everyone he stops to greet. After his 1994 appointment to the venerable Mercantile Library in downtown Cincinnati, he worked with an enthusiastic membership to reincarnate the Mercantile as the literary center of the city. The Young Men's Mercantile Library Association was founded in 1835 and has barely ticked off the years in its 10,000 year lease at its Walnut Street home. Under Pyle's stewardship, the library's mission has grown to much more than books—its reading room hosts frequent author lectures, readings, recitals, discussion groups, and community forums. Albert Pyle is also known as "Dr. Know" who answers all manner of arcane questions for Cincinnati Magazine. Pyle is shown here with someone of even more imposing stature, the marble figure of "Silence," who arrived at the Mercantile in 1856.

Greg Hand
Hand is an enigmatic figure, a veritable mystery man who exists for most of the University of Cincinnati community as the sender of emails of warning and advice about weather, crime, changes in policies and positions, and informational news releases from Bearcat Nation. Seldom seen but always a presence lurking in Cincinnati's shadows, Hand has inspired a cult of devoted student followers who have created Facebook pages and websites dedicated to seeking him out. The legendary Mr. Hand is also a dogged historian, uncovering the origin of the Bearcat mascot, the creation of the Red and Black college colors, and the development of a score of other UC traditions that sustain the university's ties to its city.

INDEX